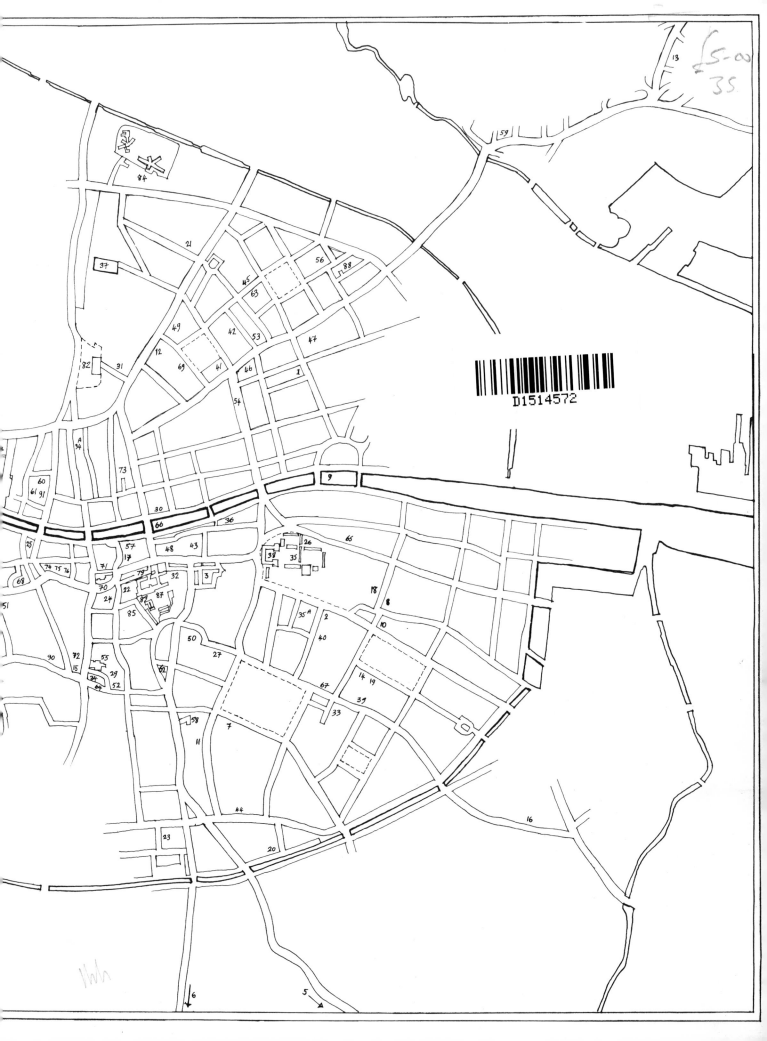

DUBLIN

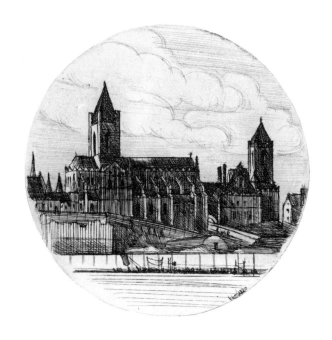

Etching of Christ Church Cathedral and Wood Quay

Also by Brian Lalor

THE JERUSALEM GUIDE
(with Diane Shalem and Giora Shamis)

THE JERUSALEM FOLIO

CORK
(with Eiléan Ní Chuilleanáin)

DUBLIN

NINETY DRAWINGS BY

BRIAN LALOR

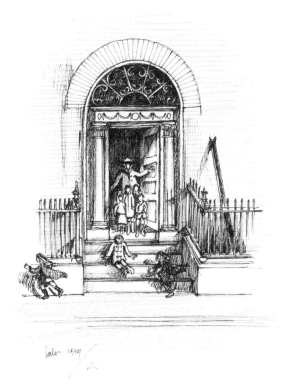

I Waterford Street

ROUTLEDGE & KEGAN PAUL
LONDON, BOSTON AND HENLEY

For Joan and Fergus Lalor

First published in 1981
by Routledge & Kegan Paul Ltd
39 Store Street, London WC1E 7DD,
9 Park Street, Boston, Mass. 02108, USA and
Broadway House, Newtown Road,
Henley-on-Thames, Oxon RG9 1EN
Set in Monophoto Poliphilus
and printed in Great Britain by
BAS Printers Limited, Over Wallop, Hampshire
© text and drawings Brian Lalor 1981
No part of this book may be reproduced in
any form without permission from the
publisher, except for the quotation of brief
passages in criticism

ISBN 0-7100-0809-0

CONTENTS

ILLUSTRATIONS

BELIEF

THE MEDIEVAL CITY

CASTLE AND CROWN

CONCLUSION

PANORAMA

FORMS
AND PATTERNS

AN INTRODUCTION

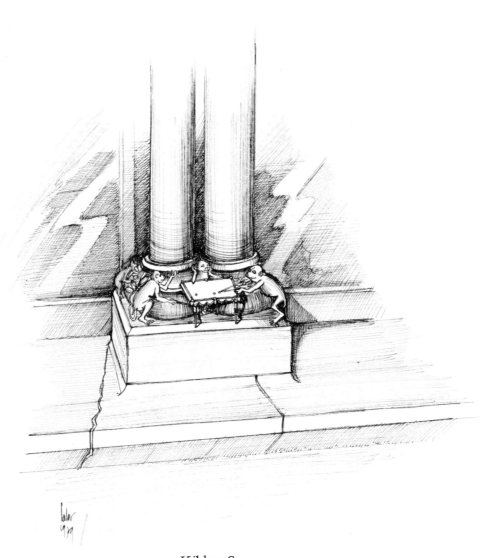

2 Kildare Street

FORMS
AND PATTERNS
AN INTRODUCTION
༄

Rome disappoints me much; I hardly as yet understand, but
Rubbishy seems the word that most exactly would suit it.
All the foolish destructions, and all the sillier savings,
All the incongruous things of past incompatible ages,
Seem to be treasured up here to make fools of present and future.
<div align="right">

Arthur Hugh Clough,
Amours de Voyage, 1849
</div>

In considering the experience of spending a long period in the streets of Dublin, entirely engaged in drawing the city, a comparison with similar work I have done elsewhere and in like circumstances seems relevant. Two other cities on which I have done books of drawings, Jerusalem in 1972 and Cork in 1974, provide adequate room for comparison in the nature of the task, even if these cities have otherwise little in common. The problems are primarily twofold, artistic and social.

In Jerusalem, a city where ancient and modern are rudely juxtaposed, my activity was outside the pale of the acceptable amongst the Orthodox Jewish and Muslim inhabitants, so the problems were mainly social. The proscriptions against figurative art adhered to by the more rigorous followers of both religions led to a common reaction of antagonism verging on hysteria. This reaction was not confined to any age group amongst the inhabitants, but children were often the most active in pursuit of the artist, expressing their opinions with well directed spits and stones. Their elders participated or looked on with righteous approval. This attitude can be characterized by an antagonism based on a clear conviction and conception of the acceptable and its converse, and also a hatred of the unknown.

As well as the religious proscriptions against figurative art, there is a common superstition concerning the Evil Eye which preoccupies the more traditional societies around the Mediterranean basin. These conditions are unpromising for the artist whose work takes him out of doors. The diagrams and hieroglyphs I was seen to be putting on paper were bound to be the practice of the Evil Eye! After the physical difficulties of such a reception, the artistic problems of drawing beautiful and exotic buildings and scenes of a fascinating place and people were sheer pleasure. This is not to suggest that art is without its following in Jerusalem, an immensely cosmopolitan city abounding in art galleries,

but that the people of the alleys and marketplaces and the custodians of the shrines do not share the more enlightened concerns of the gallery-goer.

In the streets of Cork there was no united front either against the artist and his work, or in his favour, the prevailing religious attitude to art, in this case, being a favourable one, even if expressed in various excesses of bad taste. A polite acceptance of the eccentricities of others, even sympathy that a grown man might be so foolish as to spend his time drawing street scenes, gave a general benevolence to the reaction of the people. My sojourn in that city began well with much hospitality from the inhabitants of the myriads of lanes and alleyways which run like spider-webs over the hills. Neighbours vied with each other to provide tea, biscuits and chairs for my comfort. The converse of this was being set upon by drunks who wished to have their picture drawn, and being pursued by an unpleasant variety of maniacs and misfortunates whose objection to my work was on a more instinctive level. Parallels between artists and policemen cannot be many, yet while working on my drawings of Cork, I became aware that, of those who live in the street and are not primarily concerned with survival, the artist and policeman share a like attitude of scrutiny even if for rather different purposes. The physical nature of Cork, a river valley, with the city straddling precipitious hills, provides much material for the artist's eye. Although neither grand in scale nor exceptional in any other way, a pleasing juxtaposition of man-made forms and a naturally dramatic setting give this city a body of abundant character.

Dublin presents a different situation from either Jerusalem or Cork. It is a capital city, a university city, and the centre of the greater percentage of the artistic, literary and political activity in Ireland for the last 300 years. It is a city with much fine architecture, monumental sculpture, and majestic boulevards. However, for all this grandeur and these seats of government and learning, the position of the artist in relation to society remains an essentially ambiguous one. Anarchist, incendiary, spy – somewhere between these lies the core of the reaction of many Dubliners in the streets and also in official positions to the simple and presumably innocent purpose of doing drawings of people and places.

The most prevailing of all reactions was that of the inhabitants of any slightly less than perfect building. This of course means practically all the buildings in the central area of the city. These people assumed, and, despite my protestations remained convinced, that I was an agent of the common enemy of the people of Dublin, the Corporation. Repeatedly I was identified with this apparently obnoxious and alien body, and the assumption made that whatever I was drawing would shortly be condemned and subsequently demolished – a recurrence of the Evil Eye syndrome, but with a great deal more justification than where I previously encountered it.

Having with some difficulty convinced individuals of the baselessness of their suspicions, even to me the swift disappearance of familiar streets and entire areas of the

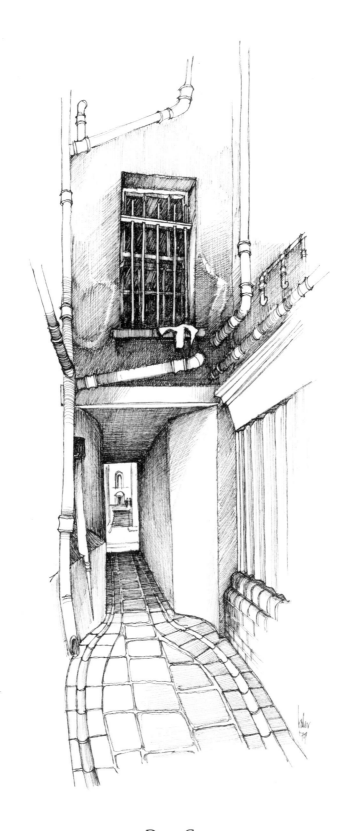

3 Dame Court

inner city seemed to give the lie to my protestations. In official circles, suspicion also characterized the reaction to my requests for admission to this or that building and turned what began as an attempt to pursue artistic ends into a struggle with bureaucratic procedures.

The physical fabric of Dublin, resembling at present some European city emerging from the ravages of the Second World War, presents to the artist a dejected spectacle. The fate of the cities of the North of Ireland has been silently and insidiously visited on the capital of the Republic without a shot being fired. In this case the subversives sit on the Corporation and in the board rooms of finance. Architectural cohesion, so much a part of Dublin's finesse in the past, has been replaced by an abandonment of all principles. 'Rubbishy seems the word that most exactly would suit it.'

In the problem of what way to present Dublin, I have chosen a thematic approach, partly aesthetic, partly historical. The eighteenth-century core of the city, rather than being represented by a single overpowering section which its bulk and influence would warrant, has been divided and distributed throughout the book. The Georgian idiom appears and reappears in every theme short of the medieval. One is never far from some aspect of the eighteenth century in Dublin. Its restrained and rectangular forms become the prevailing character of the landscape.

Presented here are some of the parts of this urban landscape. Still beautiful in a few aspects, in many others, however, it is deformed and barren. But these warts have their meaning, even if they lack beauty. Although Dublin in the late 1970s tends towards the ugly, the inhuman and the styleless, it is not yet too late to restrain this decline into anonymity and mere functionalism.

In the eighteenth century the spacious, beautiful, residential areas reserved for those of wealth and privilege contrasted harshly with the teeming and unhealthy slums of the old parts of the city where the less fortunate dwelled. In a less egalitarian age than the present this was common in any city of Europe and as such was acceptable. That these contrasts still exist in the Dublin of today is neither necessary nor acceptable. A city is for being lived in, and that does not imply pure survival. Humanistic rather than solely economic or functional aims must prevail if Dublin is to regain its heart as a living and beautiful place.

The ideas of the Enlightenment were to give *to* the citizens, rather than to take away, and this did not mean the wealthy alone. Some of this vision, rather than spiritual barrenness, is needed if Dublin is to retain its identity as a city that delights the eye, and in which living is an enriching experience.

The drawings in this introductory section comprise a miscellaneous collection of the forms and patterns which make up the city. Material which may seem arbitrary in its choice is in fact extremely relevant to the unperceived city, that is, the daily environment of

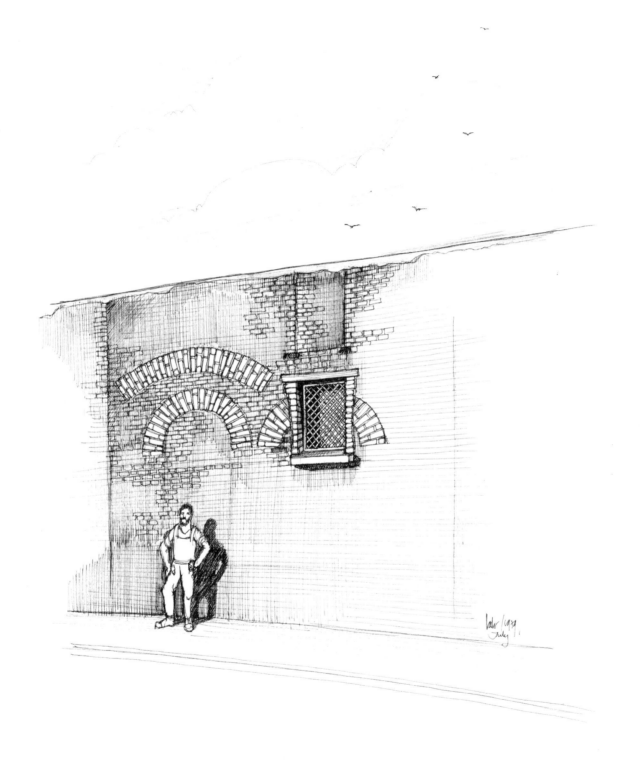

4 Ardee Street

lane and pavement, short cut and back yard; that which is passed by rather than consciously viewed, yet which becomes an integral part of the individual's subconscious landscape. The ragged life of the tenement contrasts harshly with the secure calm of its suburban counterpart, yet neither are quite what they seem. All the small details combine to make up the picture. The river which appears here as elsewhere is for Dublin a theme in itself and fittingly so. Once a busy thoroughfare, it remains now an enlivening strip of light amongst the dull masses of the buildings, crossed and recrossed in the course of a day's city life. It is more lived with than looked at. Soft textures of brickwork and hard pavements of stone form the shapes of this rectilinear city. The ever-present archways and greenery set off both the colour and the straight line.

5 Beechwood Avenue

6 Castlewood Avenue

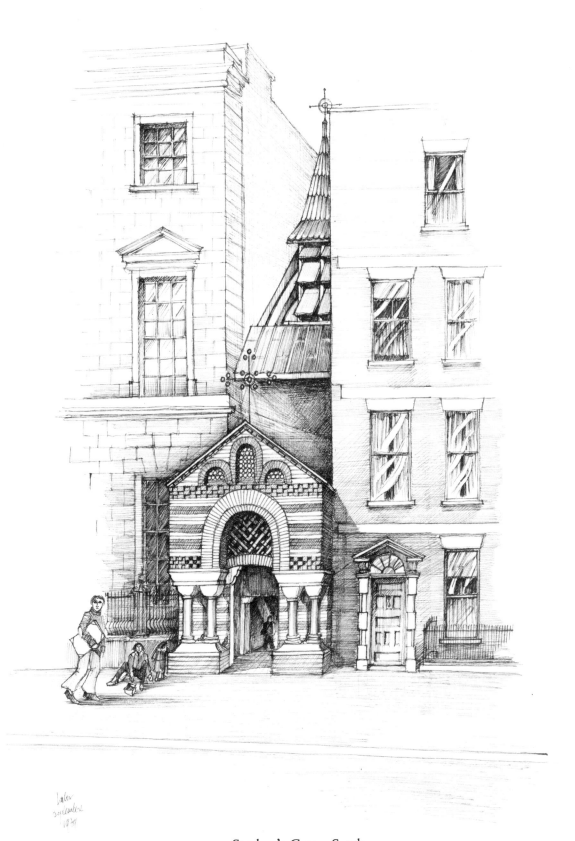

7 Stephen's Green, South

8 Westland Row

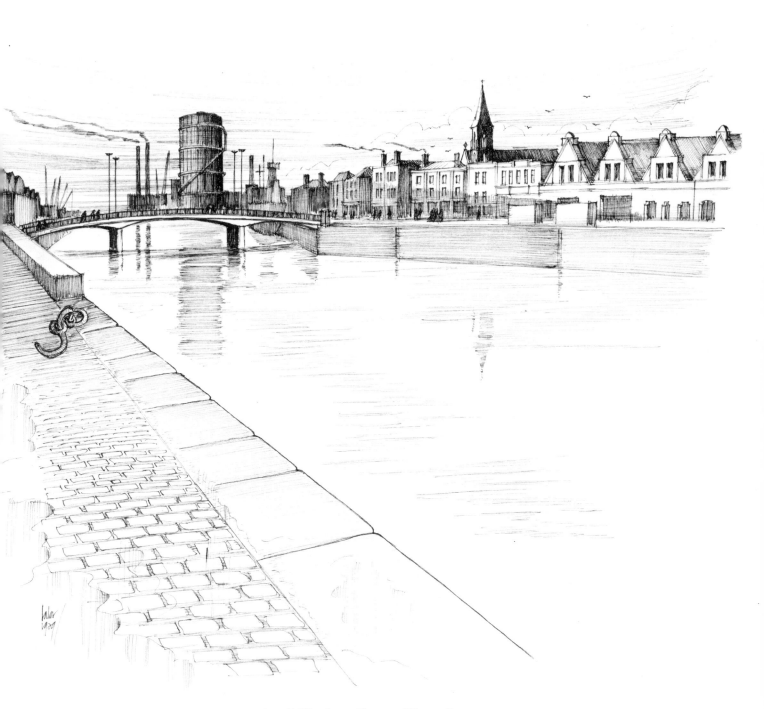

9 River Liffey from Custom House Quay

THAT GOODLY
COMPANY

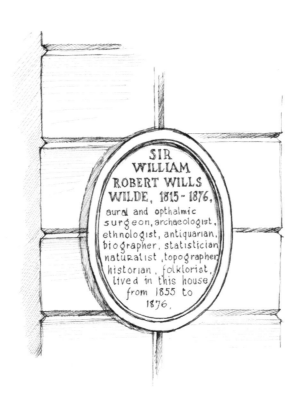

10 No. 1 Merrion Square

THAT GOODLY
COMPANY

⟨⟶⟩

Not Beggar's Brat, on Bulk begot;
Not Bastard of a Pedler *Scot*;
Not Boy brought up to cleaning Shoes,
The Spawn of *Bridewell*, or the Stews;
Not Infants dropt, the spurious Pledges
Of *Gipsies* littering under Hedges,
Are so disqualified by Fate
To rise in *Church*, or *Law*, or *State*,
As he, whom *Phebus* in his Ire
Hath *blasted* with poetick Fire.
　　　　Jonathan Swift,
　　　　'On Poetry: – A Rhapsody', 1733

The fire which blasted many of those whose associations are gathered here was not only that of poetry but the brimstone of the other Muses as well. Some had the luck or perception which enabled the pursuit of their muse not to end in chaos. Many were less fortunate, and their lives are chronicles of penury, misfortune and disaster.

Architecture has in its origins a certain integrity, in that a building rarely belies its purpose. This integrity cannot, however, always be applied to those who subsequently inhabit a building. The outward signs of prosperity may conceal its opposite, and the drawing of definite conclusions from where a certain person lived becomes fraught with difficulty. Any area of a city may have altered its atmosphere radically with the passage of time, and even in its relevant period appearances may have been deceptive. The drawings in this section attempt to grasp at the relevance of certain places to those whose memory they evoke.

Between the intellectual giants who dominated the artistic life of their age, and now embody it, and the minor figures flittering amongst the shadows whose contribution is slight or forgotten, there exists a considerable body worthy of attention. Dublin in the last three centuries has been home or birthplace to many of the former, latter and middle sphere. The period between the eighteenth and twentieth centuries in this city nurtured some, harboured others and sent yet another group off beyond its narrower confines, to give and take from the cultural life of other countries and continents. To say what

17

indelible mark this city of their origins, the people and environment, had on the last group is difficult, and unprovable at best. Yet these relationships are at least sufficient to justify inclusion here, even if the work for which individuals became known was done after their departure from their birthplace.

Dublin in the eighteenth century saw two of the greatest figures of the age, one long and half-reluctantly, the other briefly though not less memorably. Jonathan Swift and George Frederick Handel, whose periods in Dublin barely coincide, unite two great streams of fertility and genius. Swift had reached the point of decline; Handel was approaching his zenith.

What little remains of the Dublin most closely associated with Swift is fast disappearing. Much of it was already gone by the beginning of this century: the Deanery itself, and the characteristic houses of the Liberties. The single great monument to his memory, St Patrick's Cathedral, where he was Dean for over thirty years, dominates the area of the Liberties now, much as it must have in Swifts's lifetime. It is an uncomfortable reflection on the city and its people for whom he cared and on whose behalf he exercised his talents, that over 200 years after his death there is no statue to this man, amongst the plethora of bronze and marble patriots who overlook the streets.

On 13 April 1742 the *Messiah* Oratorio was first performed at the newly opened Music Hall in Fishamble Street, the composer, Mr Handel, conducting. Fishamble Street is now a few ruinous buildings on a street running uphill from the Liffey to the eastern end of Christ Church Cathedral. Of the Music Hall itself, only the battered relic of a once elegant archway, standing in a corner wedged between a brick house of the eighteenth century and a business premises of the nineteenth marks its position. A bronze plaque on the former commemorates the event.

Exactly forty years after the *Messiah* was performed in Fishamble Street a child was baptized in St Werburgh's Church a few hundred yards further uphill from the Music Hall. This was John Field, the only major composer to come from Dublin in the eighteenth century. Although his life as a performing musician and composer was spent abroad, his early and formative musical education was received in Dublin.

Going from the already devastated areas of the city associated with Swift, Field and Handel to the North Side of the Liffey, one finds the crumbling and leprous remains of great mansions which evoke many past events and people. In Upper Dorset Street the playwright Richard Brinsley Sheridan was born into a theatrical family in a house now bleakly standing between a pub and a convent. The remnants of the north of the city that have so far escaped being shoved into oblivion by the hand of a very dubious progress can even in the best preserved streets manage only a gap-toothed expression of survival. These buildings and the ghosts of those greater and lesser people who make up the history of Dublin in past centuries may soon be annihilated by the years of progress to come.

11 No. 16 Harcourt Street

In the nineteenth century Dublin provided birthplace and residence for a wealth of the creative spirit. Some of the bearers of this spirit were doomed, damned, demented; others, more fortunate, were to achieve greatness without a sacrifice of life or sanity. The approach of the antiquary guides much of the literary archaeology of Sir William Wilde and James Clarence Mangan, near contemporaries, whose lives were tragic in their separate ways. Wilde, a veritable Renaissance man in the multiplicity of his interests and talents, was in his professional life highly successful, eventually living in Merrion Square, the apogee of elegance and professional success. Mangan eked out his life in miserable conditions working as a scrivener, his 'grand Byronian soul' burning out at forty-six.

William Carleton, though not born in Dublin, lived the major part of his creative life in various parts of the city. Unlike many in the intellectual life of Dublin, he was a countryman. He belonged to that alien other world of Gaelic rural Ireland which existed in the Augustan Age but was largely uninfluenced by its ideas. It was from this background that he drew the fund of novels and stories of Irish peasant life that splendidly capture the world of the people outside the capital. Carleton lived for many years in Fairview, then a village on the outskirts of Dublin, at Marino Terrace, now Malahide Road.

The dignified eighteenth-century streets of what is now central Dublin, though on its fashionable periphery when they were built, have abundant association with peers, ecclesiastics and writers. Bram Stoker, born not far from Carleton's house at Fairview, had rooms in Harcourt Street. A few doors away was the former residence of Sir Jonah Barrington, that great chronicler of fact and fable in the lives and bacchanalia of the gentry.

Across Stephen's Green and off its eastern corner in Merrion Square lived another writer of the supernatural, Sheridan Le Fanu. This square, as the only major survivor of a polished and affluent society, has been a common address for many famous and infamous names. Sir William Wilde lived on the north side of the square in the corner house, a short distance from Westland Row where his now more famous son, Oscar, was born. On the south side of the square amongst a long list of famous Dubliners and Irishmen the name of W. B. Yeats stands out. He had a house here in the early years of the Irish State.

In the rather more humble surroundings of Synge Street, George Bernard Shaw was born in a two-storey terrace house – a much scaled-down distant relative of the grand mansions of Merrion Square.

James Joyce must have lived in as many houses as any writer during his youth. The umpteen addresses between his birth and subsequent departure from Ireland in 1904 present a confusing itinerary. Between his birthplace in Brighton Square (which is really a triangle) and the circular Martello Tower at Sandycove, which holds such a formidable place in Joycean hagiography although he lived there for less than a week, lie a series of depressing suburban dwellings. The house in Eccles Street, now no more than a sightless wall,

12 No. 12 Upper Dorset Street

where Joyce's creation Bloom lived, is in many ways as appropriate a relic of the writer as the myriad of his actual residences.

Like Carleton, Patrick Kavanagh was a countryman who came to Dublin from a remote and depressed area as a young man, and made it his home for the rest of his life. For many years he lived on Pembroke Road, publishing his short-lived newspaper from there, and it is in fact central to that part of Dublin which is mentioned in his poems. Between Pembroke Road and Baggot Street runs the Grand Canal on the banks of which his memory is recorded.

The choice of persons and places that formed this section of drawings was guided by an attempt at some kind of balance. To make a visual synthesis of such a rich body of eccentric and varied characters as Dublin's intellectual life has known presents problems of quality and number. From George Berkeley the eighteenth-century philospher to Brendan Behan in the twentieth century there has been a steady succession calling for attention. Those who have been left out are hopefully represented by those who are included. For some no tangible or aesthetically satisfactory relic remains, for others every bar stool in the city is a polished shrine. 'The Brazen Head' in Lower Bridge Street must act as a sponsor and spokesman for all who have been omitted, for, as the oldest pub in the city, its memory must be as rich as its acquaintance is wide.

13　No. 28 Malahide Road

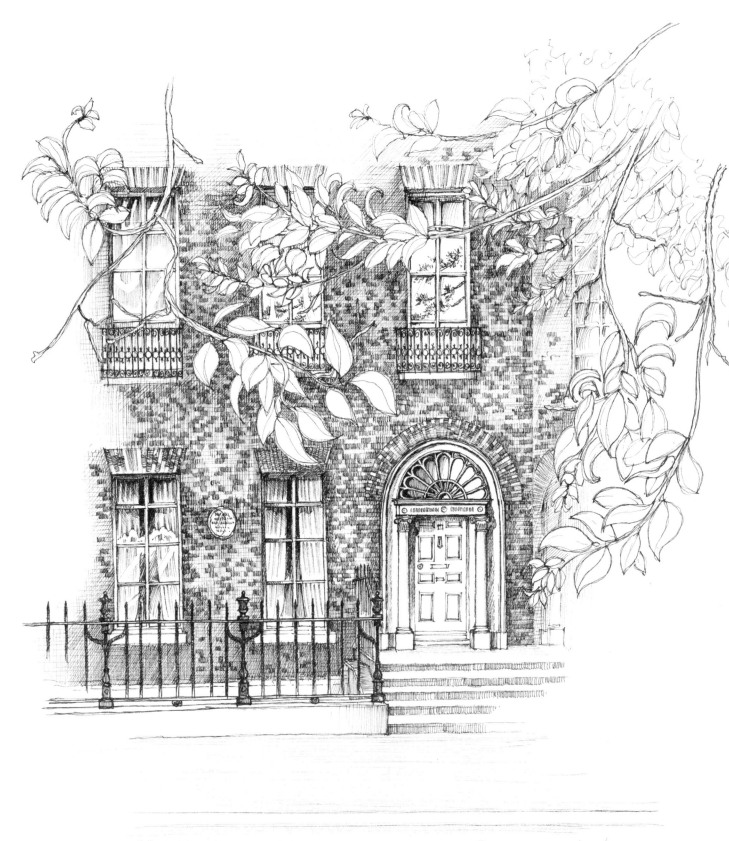

14 No. 82 Merrion Square

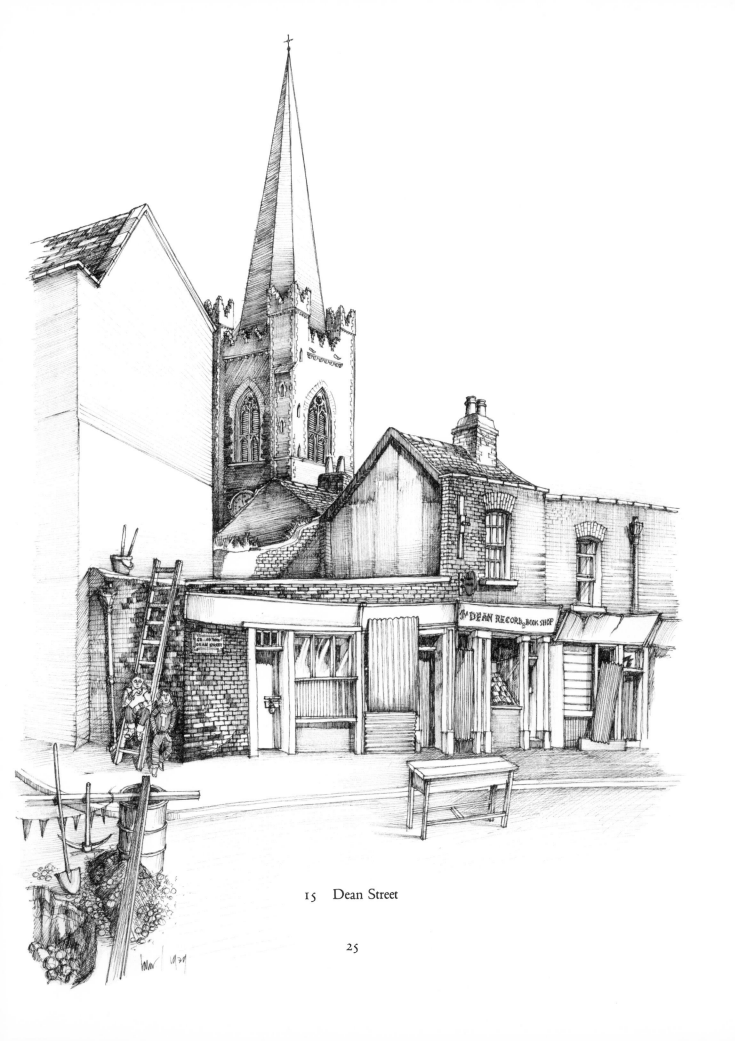

15 Dean Street

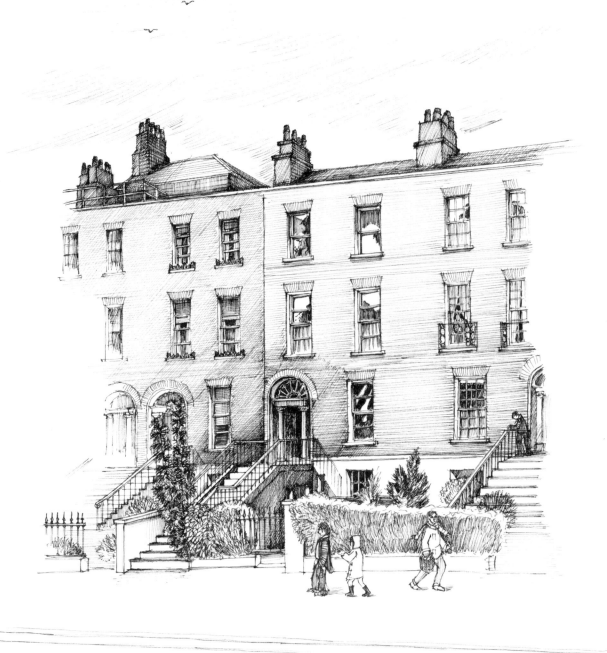

16 No. 62 Pembroke Road

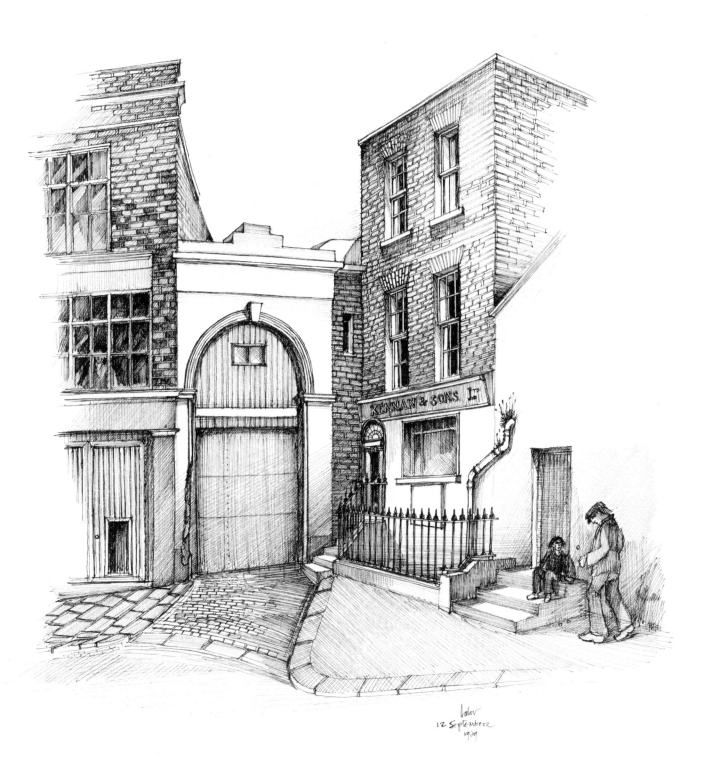

17 Fishamble Street

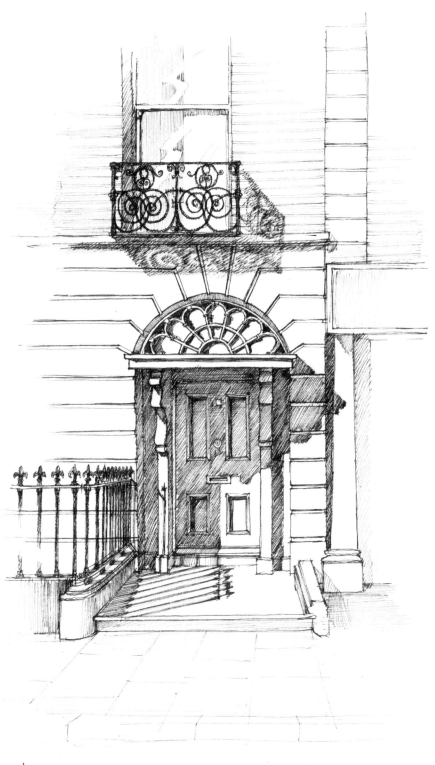

18 No. 21 Westland Row

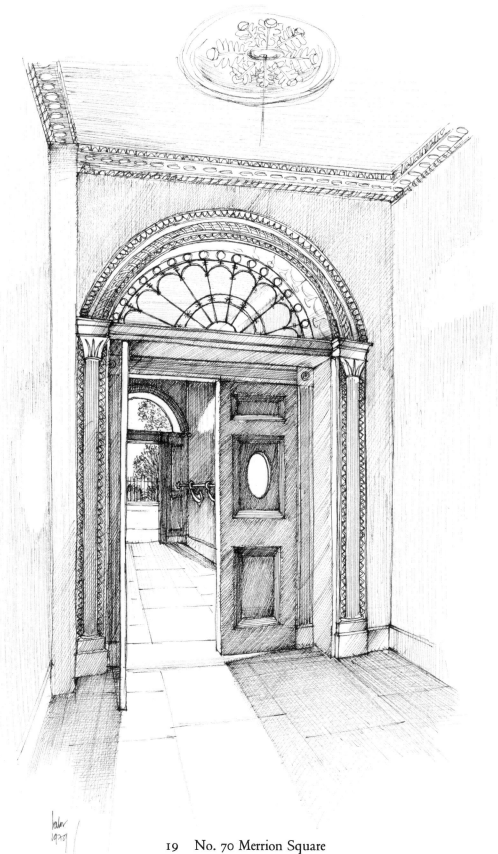

19 No. 70 Merrion Square

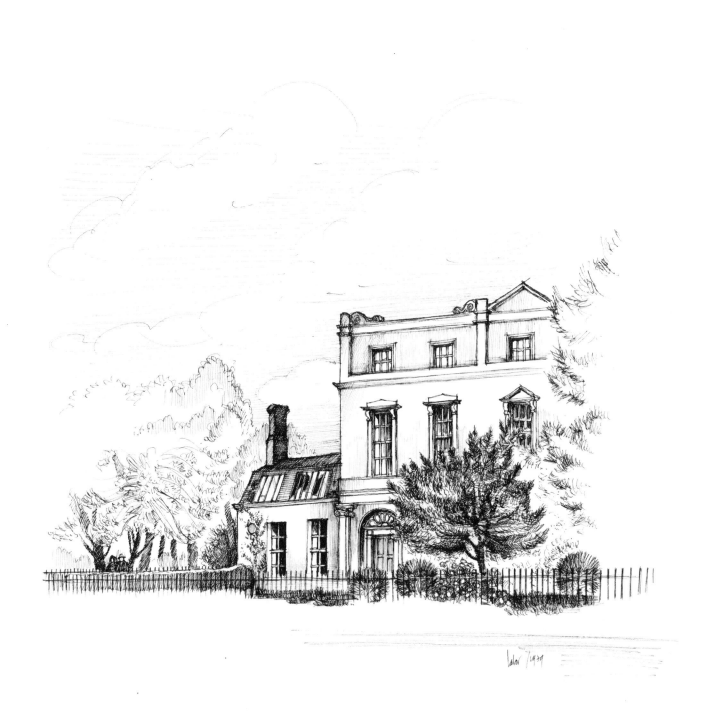

20 No. 11 Harcourt Terrace

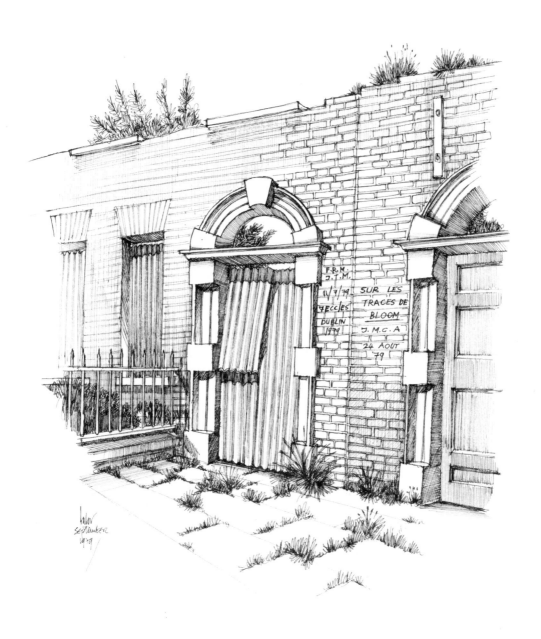

21　No. 7 Eccles Street

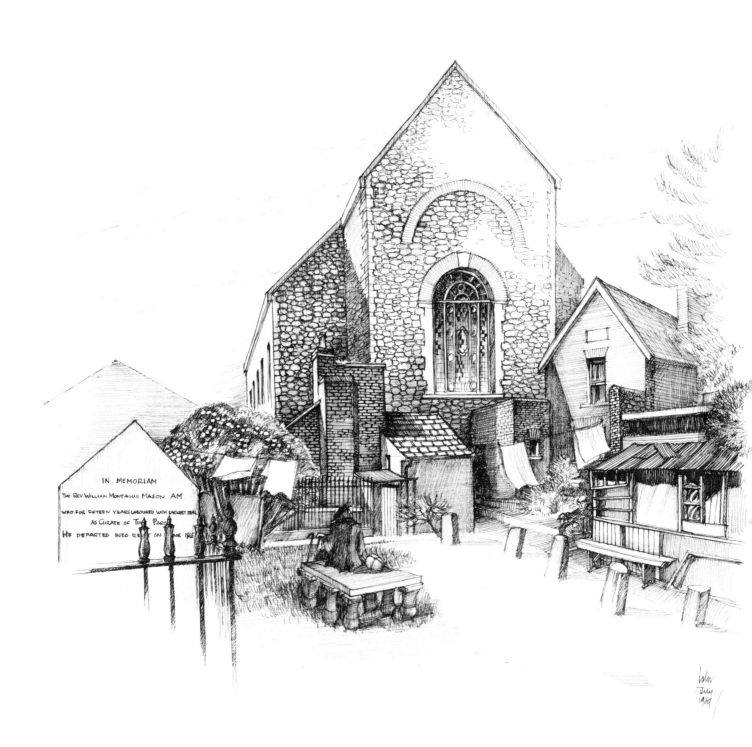

Within the image:
IN MEMORIAM
THE REV WILLIAM MONTAGUE MASON AM
WHO FOR FIFTEEN YEARS LABOURED WITH EARNEST ZEAL
AS CURATE OF THIS PARISH
HE DEPARTED INTO REST ON JUNE 1865

22 Werburgh Street

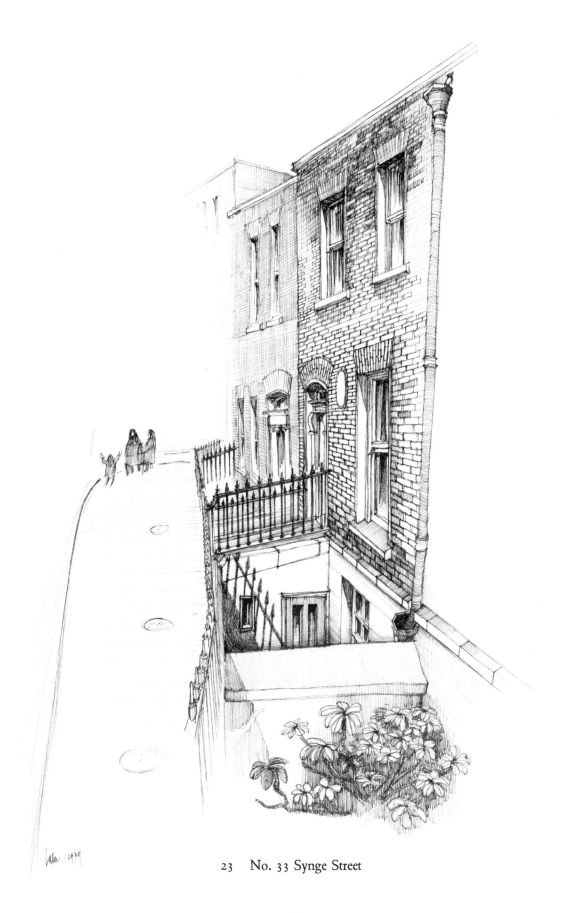

23 No. 33 Synge Street

24 Werburgh Street

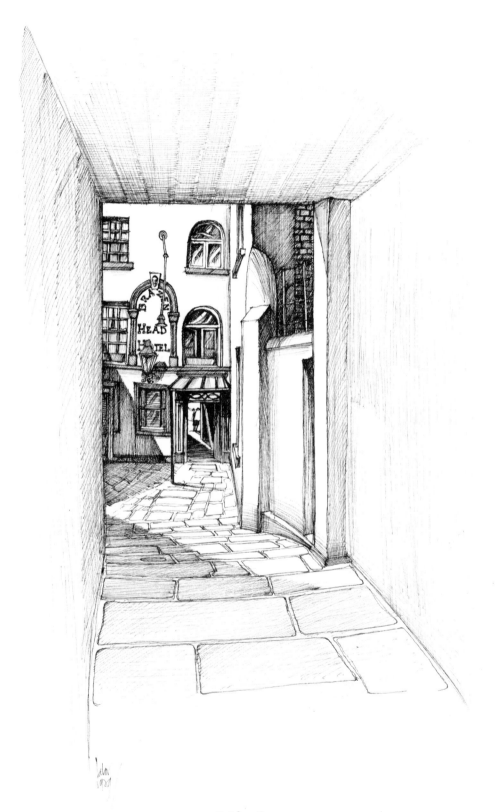

25 Bridge Street

THE
AGE OF REASON

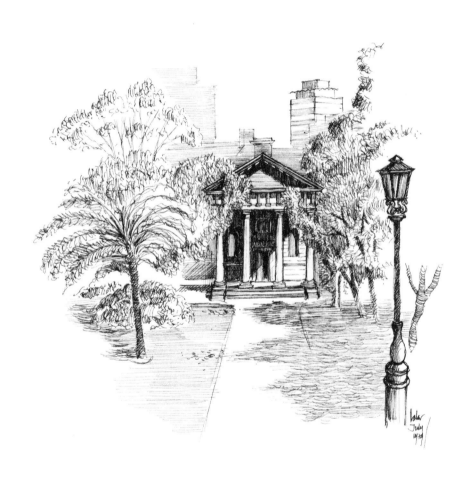

26 Trinity College

THE
AGE OF REASON

The sound rules of the Grecian Architecture are not to
be lightly sacrificed. A deviation from them, or even
an addition to them, is like a deviation or addition to,
or from, the rules of other Arts — fit only for a great
master, who is thoroughly conversant with the nature of
man, as well as all conventions in his own Art.

Sir Joshua Reynolds,
Royal Academy Discourses, 1786

The advent of the Age of Reason in late seventeenth-century Ireland is marked splendidly in architectural terms. The particular landmark is a building which must be amongst the least known and even less viewed of Dublin's great public buildings. This is of course the Royal Hospital at Kilmainham. The Hospital resembles more an Ottoman Kahn with arcades and minaret than any of the subsequent major eighteenth-century public buildings which embellish the city. This remarkable hospice has been gradually, in its 300 years of existence, sinking into decay and neglect. The importance which it merits as the first great secular public building in post-medieval Ireland has been ignored. Another level of importance which the Hospital occupies is in its unique position as the antecedent of Dublin's great architectural set pieces — the Parliament House, Trinity College and Merrion Square — which otherwise seem to be born out of a void. The Royal Hospital emphasizes a continuity which is essential for an overall view.

Within the city, from the beginning of the eighteenth century and lasting over 150 years, a series of energetic surges of building developed the form of Dublin as it is today. Noble streets and squares appeared, radically altering what had been an unplanned and overcrowded provincial city. This was transformed in the course of a century into one of the great capital cities of Europe, boasting of buildings and a planning concept in tune with the best current architectural thought. This Augustan city is now in decline, as the intellectual enlightenment succumbs to the greater vigour of the new financial enlightenment. Its mansions and palaces have become offices and tenements, and its churches are turned into warehouses.

From the massive bulk of the houses in Henrietta Street to the more elegant proportions of those in Merrion Square runs a line of development of the idea of a

nobleman's town house. This idea remained none-the-less remarkably constant into the early part of the nineteenth century even though the volume became less excessive and the noblemen departed. Wrought iron used in an almost obsessive manner makes the more barrack-like of the early houses more closely resemble fortresses than residences. This usage continues as one of the principal decorative themes of architecture throughout the age.

The flat and regularly punctuated façades of the variously coloured brickwork form a contrastingly gentle backdrop to the angularity of the ironwork. The enclosed basement areas and entrance steps, surrounded with this fierce black wrought iron, clearly separate the private domain from the public. In the midst of all this metalwork occurs the other important external decorative feature of Dublin's houses, the principal entrance. Excepting the often opulent decorative plasterwork in the interiors, never suggested by the street façade, the doorways of the eighteenth century are the great art form of the age. Continuously varied in a marvellously wide set of imaginative adaptations of a few simple principles, the Georgian doorway is hallmark and expression of the virility of the style of the eighteenth century.

As well as the concept of living exemplified in the eighteenth-century squares with their parkland surrounded by houses, the public institutions of the city have produced some fascinating solutions to problems of function and design. That some of these solutions are collaborations, adaptations and alterations in various times makes the talents of these architects more evident. The great room of the library at Trinity College, certainly one of the world's finest interior spaces, combines a nineteenth-century Romanesque Barrel Vault in timber with an eighteenth-century conception of a university library. The result is as remarkable and breathtaking a success as the combination is, in theory, an unlikely one. Marsh's Library, a domestic version of that at Trinity, remains largely unaltered. It is the private library of a scholar, yet on a small scale it bears comparison with its grander fellow. The atmosphere of its interior, lit by tall segmented windows, seems not to have changed in 200 years. The cloister-like courtyard and dark oak furnishings of the library have a solemn and scholastic air.

Throughout the city the flourishing interest in trade, art, science and social welfare, order above all, led to the founding of institutions to satisfy these many needs. Each institution had to have its building, and the building was required to express the dignity of the members, be they scholars, stonemasons, or a charitable institution. Such institutions as 'The Sick and Indigent Roomkeepers Society', Swift's 'House for Fools and Mad', and the many guild halls and centres of art and science have for the most part survived the ravages of time and a number still fulfil their original function. Many of the latter are amongst a body of diminutive examples of late classical public buildings such as the Merchant's Hall. A space no greater than that of an average eighteenth-century

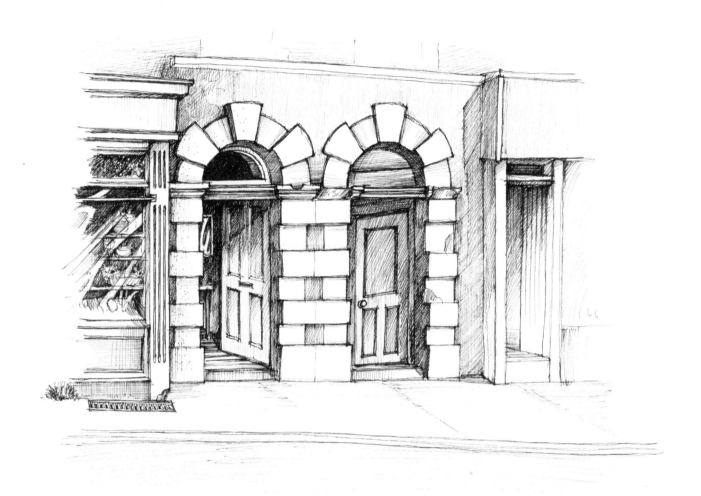

27 South King Street

business premises has been occupied with a building of modest size yet monumental scale.

The commercial life of the quays has given rise to immensely interesting almost disorderly rows of building of residential and commercial origin. The overall unity of the great streets here gives way to a chaotic abandon which only the majestic sweep of the Liffey holds together. Commerce and engineering combined with an innate aesthetic good sense has given to Dublin two waterways which, while providing the geographic boundary of Georgian Dublin, introduce into the city what are some of its most beautiful areas. These canals, 'Grand' and 'Royal', made possible the trade of a metropolis without the strangulation of its roadways. Now they lie choked with refuse and unused, viewed greedily by road engineers in a mindless enthusiasm for an unattainable machine utopia.

The spirit of house-building in the late seventeenth century still flourished in the mid-nineteenth and developed the particular Dublin idiom. In many stages, from working men's cottages with their brick façades and minute fanlighted doorways to the houses of the commerical and professional classes with their flights of steps leading to first-floor entrances, the same ideas were utilized in unceasing variations. The richness of imagination apparent in these variations upon a theme give to Dublin's domestic architecture a liveliness which while often being eccentric never lacks unity.

Comparison between the great and minor architecture of the Age of Reason and that of the present shows the latter to be lacking in many vital respects. Eighteenth-century ideas of city planning were to promote the environment as both beautiful and convenient. Despite the fact that ostentation was a part of the philosophy, the results were never inhuman. The core around which the city's development revolved was the individual, not municipal convenience alone. A sense of proportion and correct emphasis were part of the system of ideas common in Dublin throughout its development.

The discord and confusion of the streets where modern development predominates show the need to learn from the past. Tenements originally were created by areas or buildings declining in value and also by the avarice of landlords. Today the state creates the tenements and owns them.

If the legacy of the great age of Dublin is to be understood and valued much change is needed in the education of those who mould the city's form. Creating tenements and traffic chaos is not the way of progress. By putting the individual first, instead of his being crushed somewhere under the base of the pyramid of priorities which govern contemporary change, it may be possible once more to wrest the city from its return to the conditions of medieval times – chaotic, confusing and dangerous.

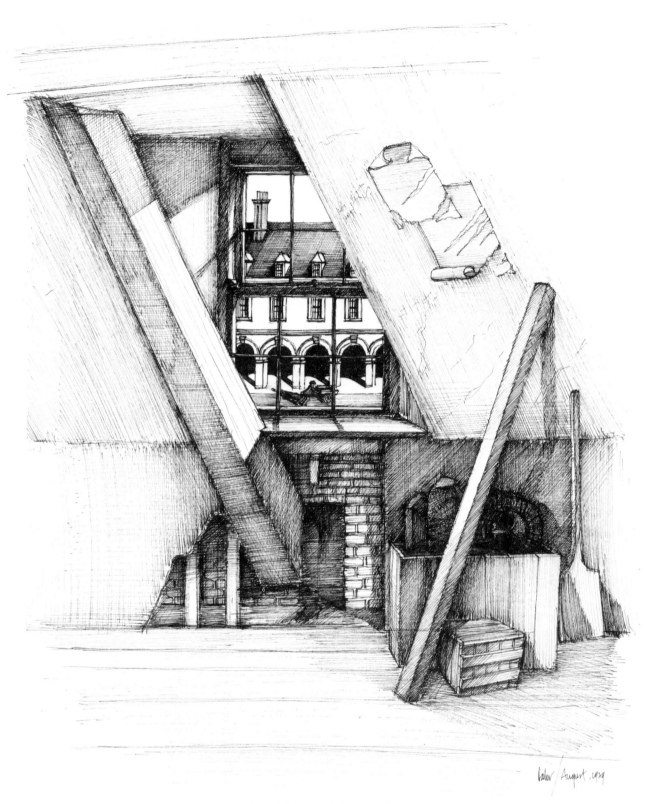

28 Royal Hospital, Kilmainham

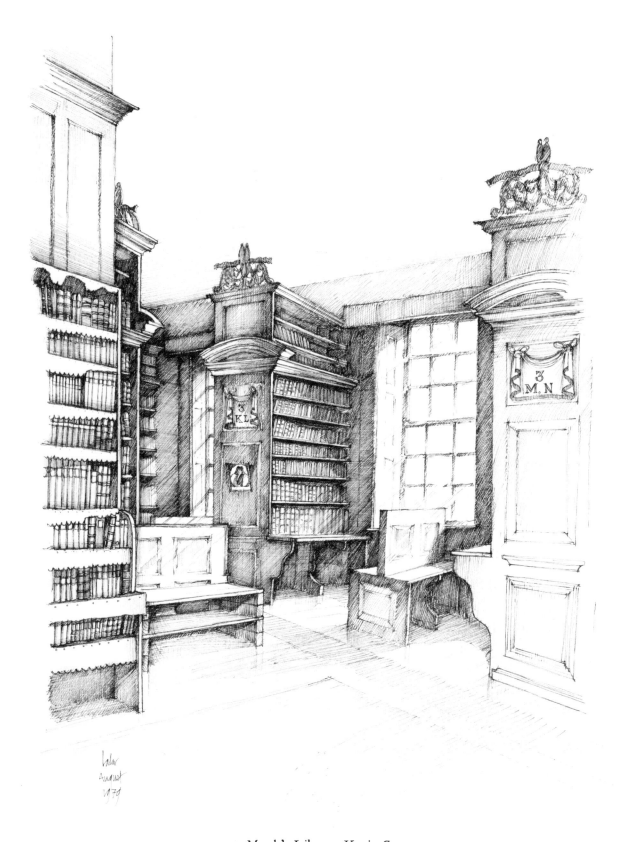

29 Marsh's Library, Kevin Street

44

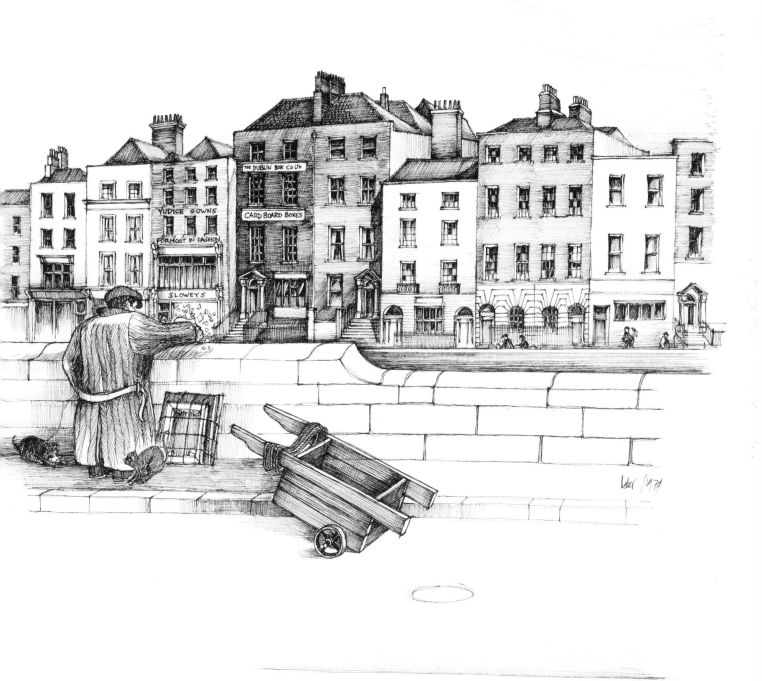

30 Ormond Quay

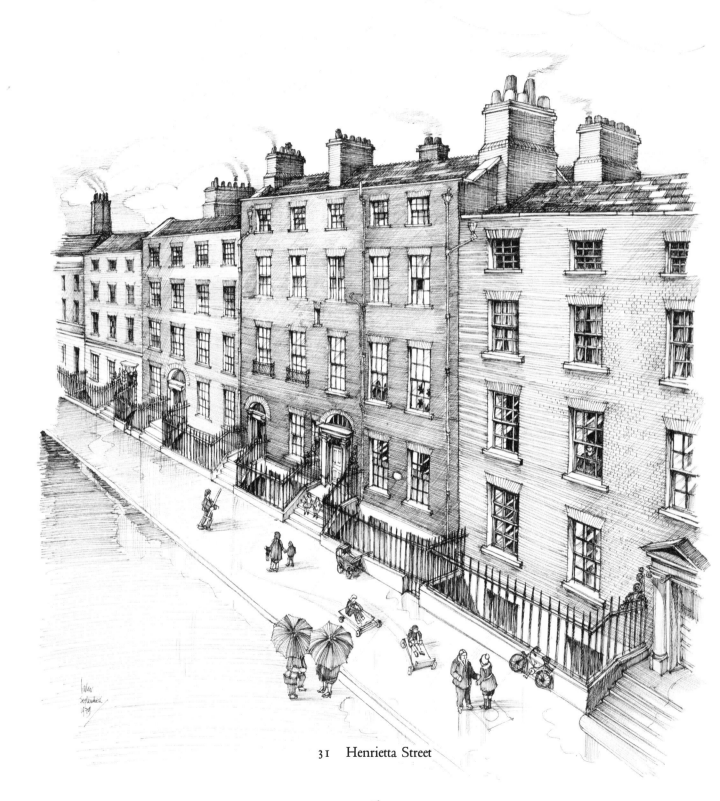

31 Henrietta Street

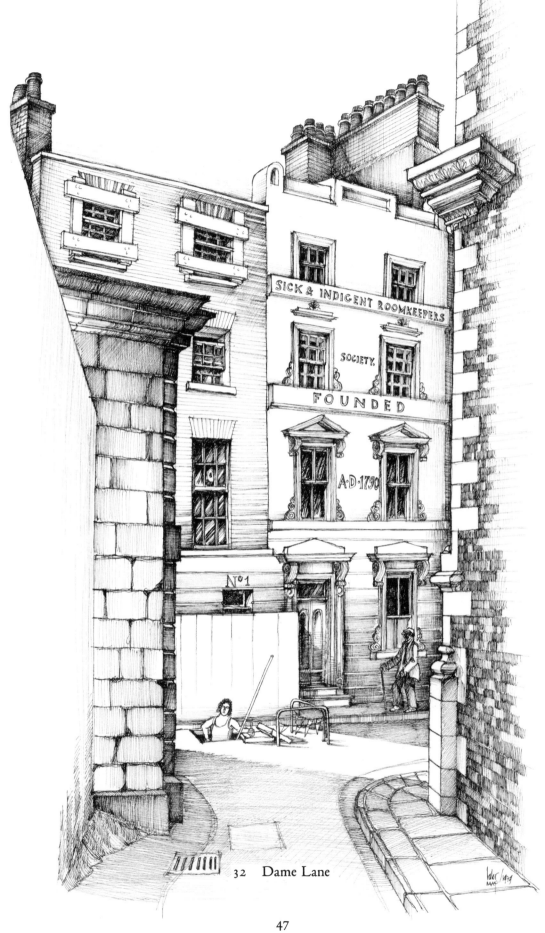

Sick & Indigent Roomkeepers
Society.
Founded
A·D·1790

No 1

32 Dame Lane

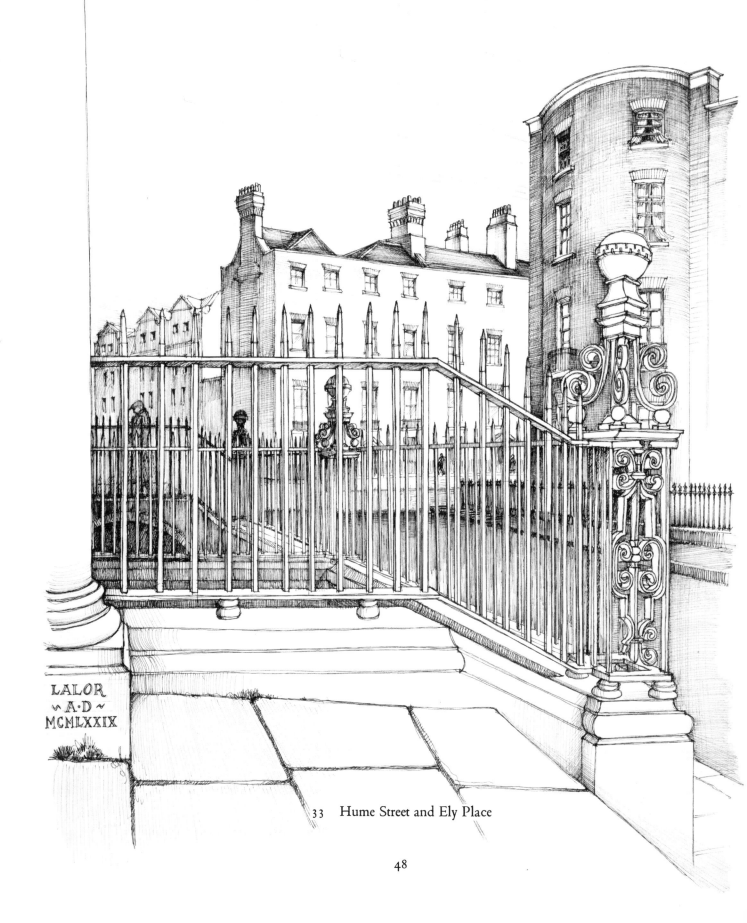

LALOR
~A·D~
MCMLXXIX

33 Hume Street and Ely Place

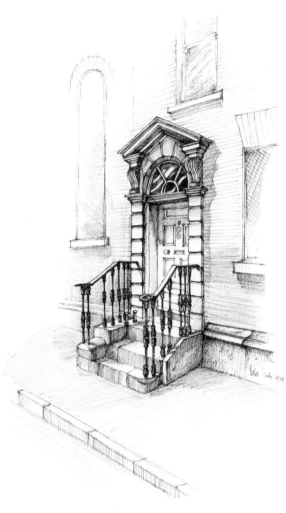

34 Patrick's Close 34A North Anne Street

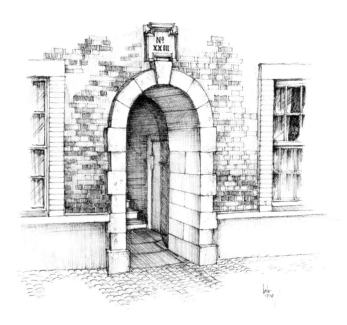

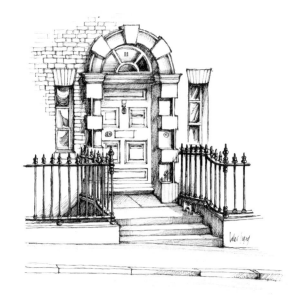

35 Trinity College 35A South Frederick Street

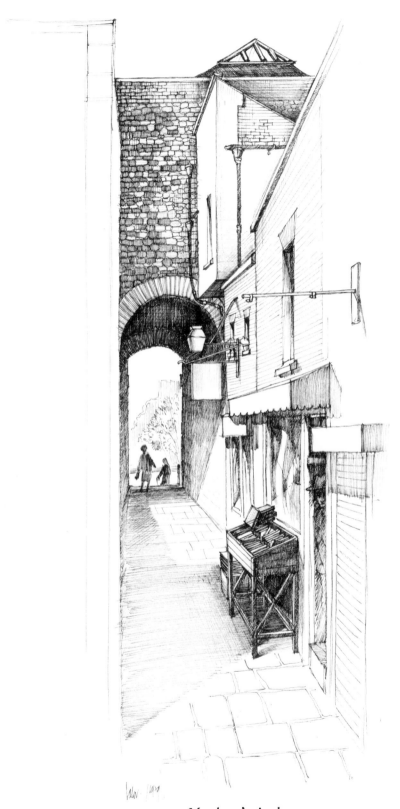

36 Merchant's Arch

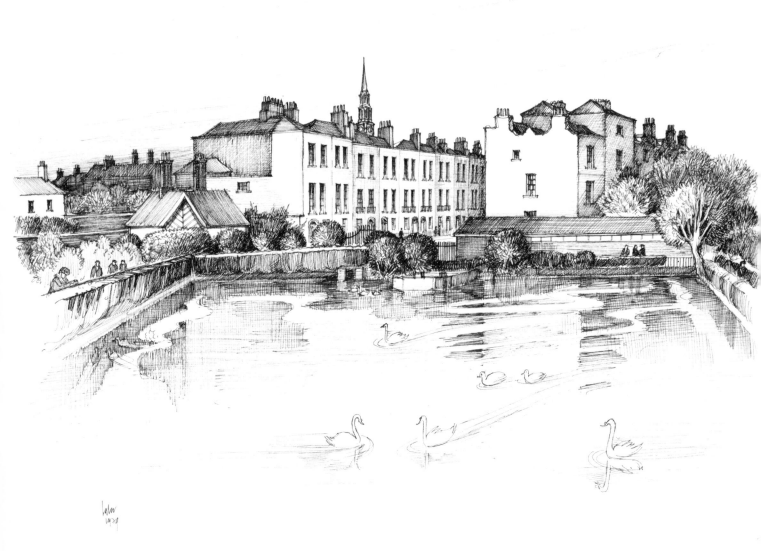

37 City Basin

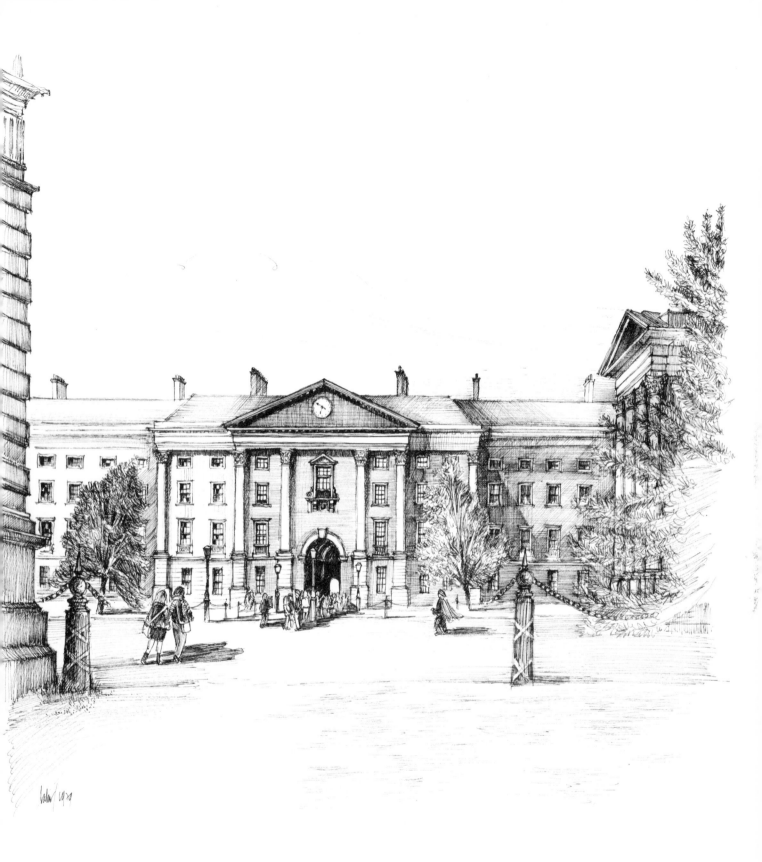

38 Trinity College

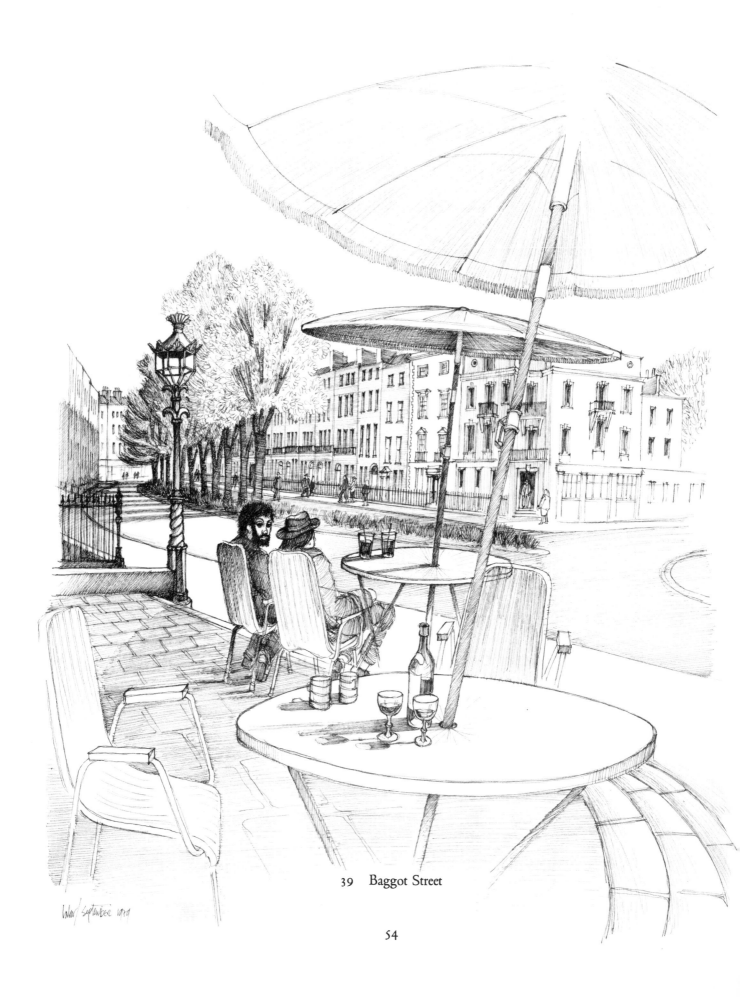

39 Baggot Street

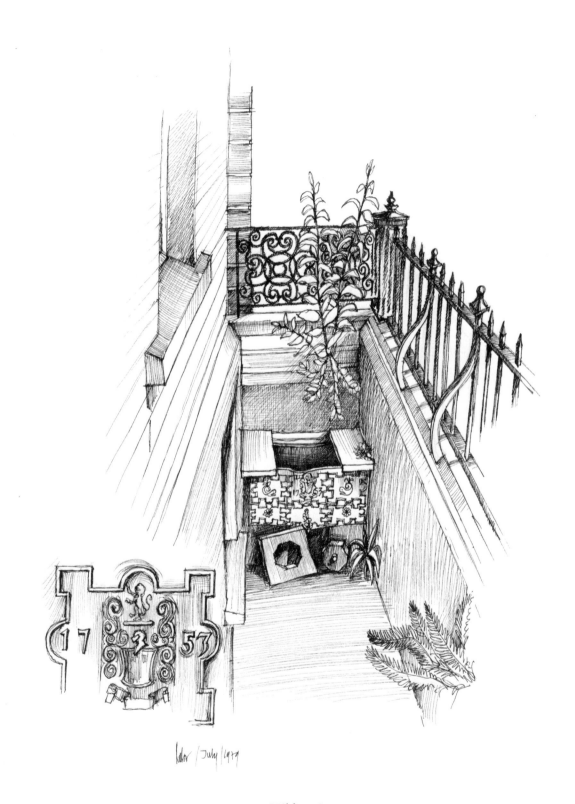

40 Kildare Street

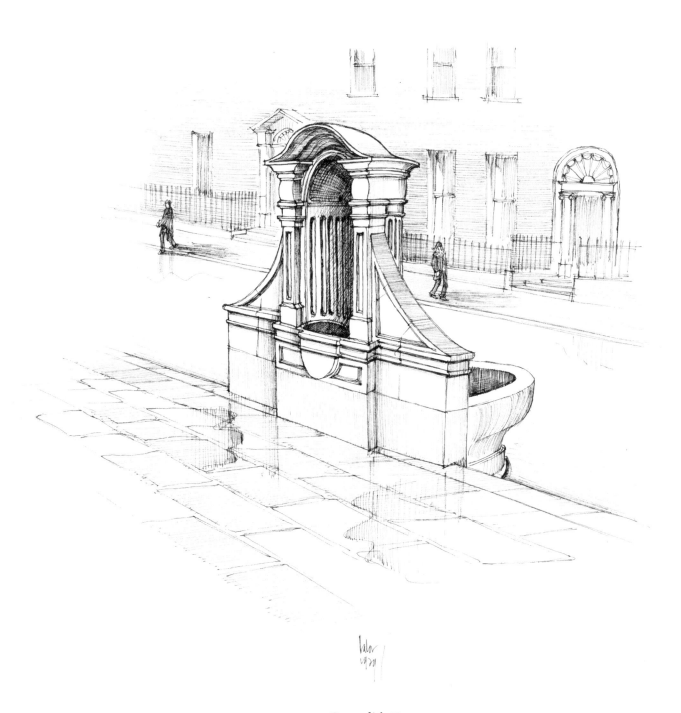

41 Cavendish Row

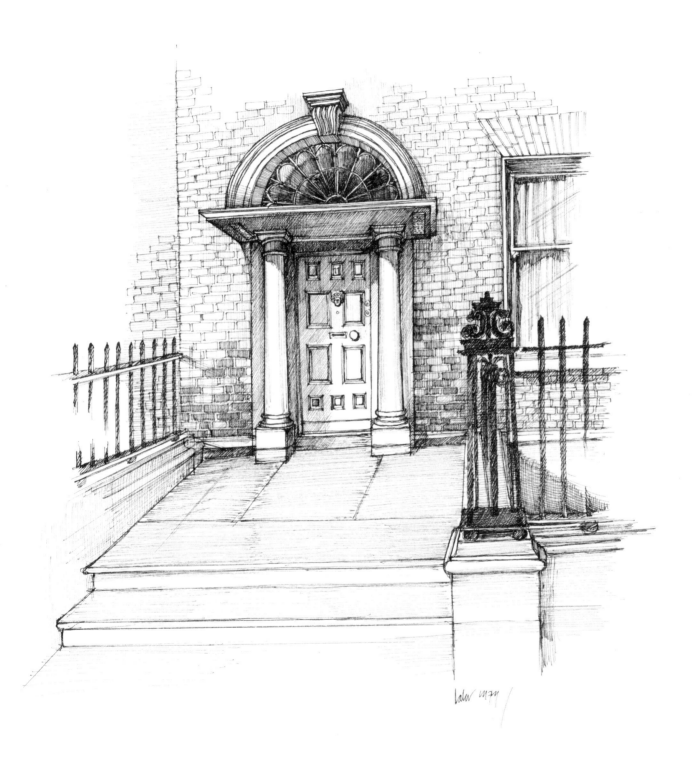

42 North Great George's Street

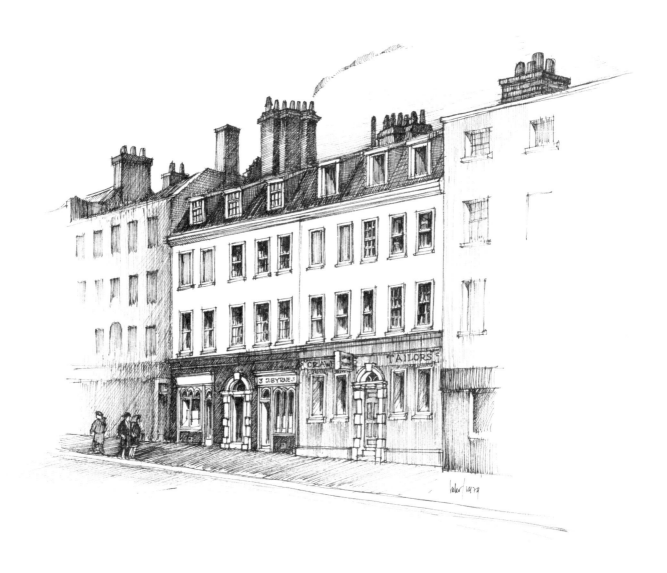

43 Fownes Street

LIBERTIES
AND SHAMBLES

44 Adelaide Road

LIBERTIES
AND SHAMBLES

᠁

Further‑more, there are so manie other extrodinarie
beggars that dailie swarme there, so charitable succored,
as they make the whole civitie in effect their hospitall.

Richard Stanyhurst,
from *Hollinshed's Chronicles*, 1577

The Liberties of the title are not specifically those areas of Dublin today known by that name, but more a reference to all the parts of the city which in the past were at one time or other the Liberties or areas of particular privilege, owing allegiance to some individual, Earl or Dean, Lord Mayor or Monastic Settlement. The only one of these rather far‑flung sections of the city to retain its title is that which today surrounds Christ Church and St Patrick's Cathedrals, and this is in fact made up of a number of different Liberties. Although the term 'Liberties' is firmly associated with the south‑west of the city, there were also Liberties north of the river and here the term is used in a more general sense.

The Shambles likewise are not alone those Shambles or market places in which street traders thrived throughout the centuries, the Fish Shambles and Flesh Shambles, but also the very evident shambles of a more contemporary sense which shows an increasing capacity to overtake the city. Of these two categories the former has all but disappeared, the latter look like becoming the dominant characteristic of the place. These areas of the city form no geographic unity, but are scattered everywhere, the remnants of this and the remnants of that, which can only be characterized by a selection of otherwise unrelated fragments of the texture of the living city.

James Malton in his splendid book of Dublin views published in 1799, which epitomizes Georgian Dublin at its zenith, calls his collection of engravings *A Picturesque and Descriptive View of the City of Dublin*. However, he manages quite skilfully in this book, which is almost an exercise in propaganda, to avoid the street scenes, the markets and the rookeries which must have been at the back of almost everything he drew. The elegant ladies and officers strolling in the Castle Yard suggest nothing of the tenements, the smells and filth to be found outside its gates. The streets of his city have a smooth surface like blotting paper, quite inconsistent with the presence of horse traffic.

Street names can tell much about an area or a period and a glance at any eighteenth‑century map of Dublin of the same general period as Malton's views shows an entirely

different picture – or if not a different one, at least the posterior as well as the anterior view. Cut Throat Lane, Murdering Lane, Cuckold's Row and Cut Purse Row are to be found in one section alone. A whole menagerie of creatures occurs in the names of alleyways, such as Dog, Duck, Badger, Goat, Cow, Bull and Horse – enough to show the closeness between the naming of places (not intended to gratify some nobleman) and a reflection of the life therein. This is a world out of Hogarth, not now to be recorded in the modern counterparts of street names. However, some echoes from the past still exist in derivations from the Irish and in modern corruptions.

In Dublin today this same aspect of peoples' lives can be found, but in a different manner expressed – not in the semi-permanence of the street and alley names but in the use of street inscriptions and graffiti. These inscriptions, which are often obscure, or personal, usually aggressive or obscene, catch the tone of 'Gin Lane' and the reek of the Shambles.

The fashionable ladies have deserted the Castle Yard for Grafton Street and elsewhere yet the ubiquitous 'sturdy beggar' present even in Malton has not left the streets of Dublin and accosts the passer-by with as much a combination of arrogance and the pathetic nature of their condition as has ever been the case.

Dublin has been lucky in the possession of a body of writers who have recorded with all the richness of language that the subject demands the life of these Liberties and Shambles. In this century alone the work of Joyce, O'Casey, Flann O'Brien and Behan have captured much of the essence of the street life, with its splendidly rich variety of accent and dialect. If indeed Dublin were to be destroyed and recreated from *Ulysees* it would not be as Canaletto's Venice basking in a Golden Age but in the pungent sounds and smells of a living and lively place, where life was a precarious business, yet to be savoured to the full while one had it.

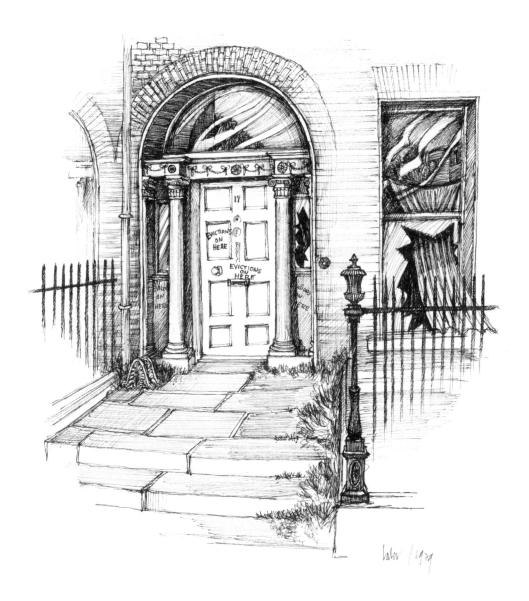

45 Gardiner Place

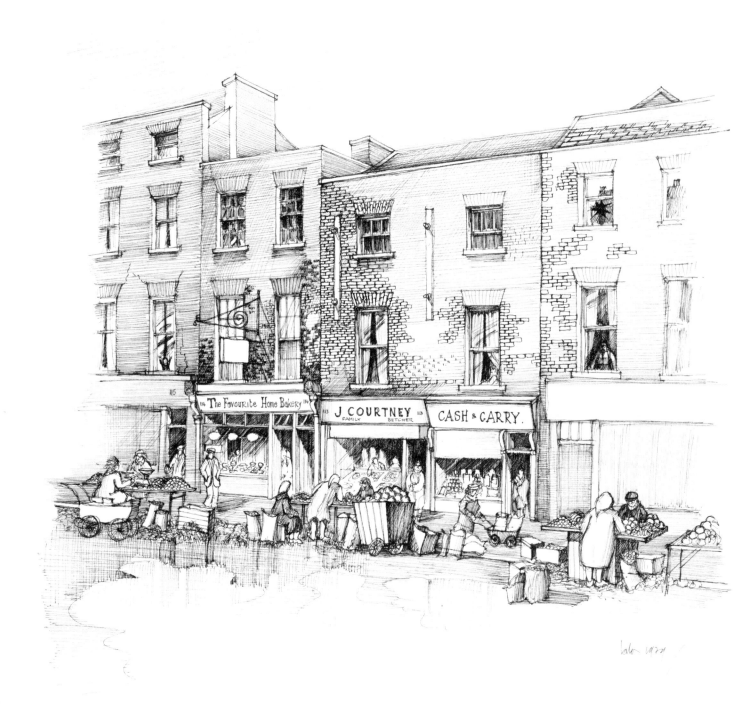

46 Parnell Street

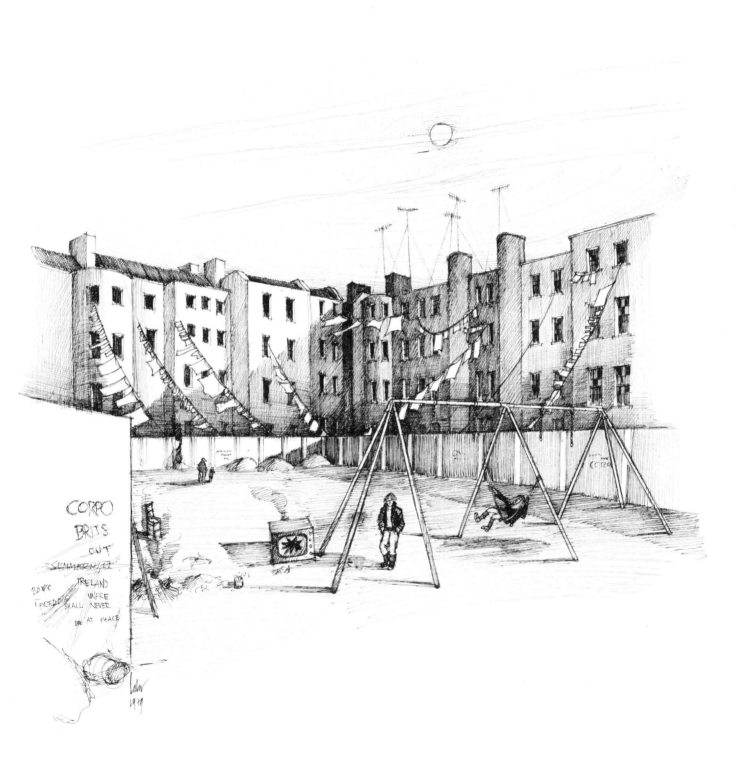

47 Gardiner Street/Sean McDermott Street

48 Crampton Court

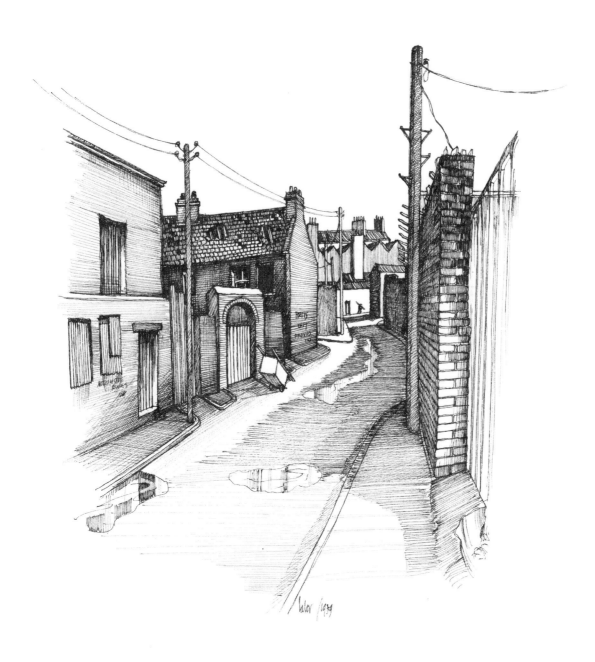

49 Paradise Place

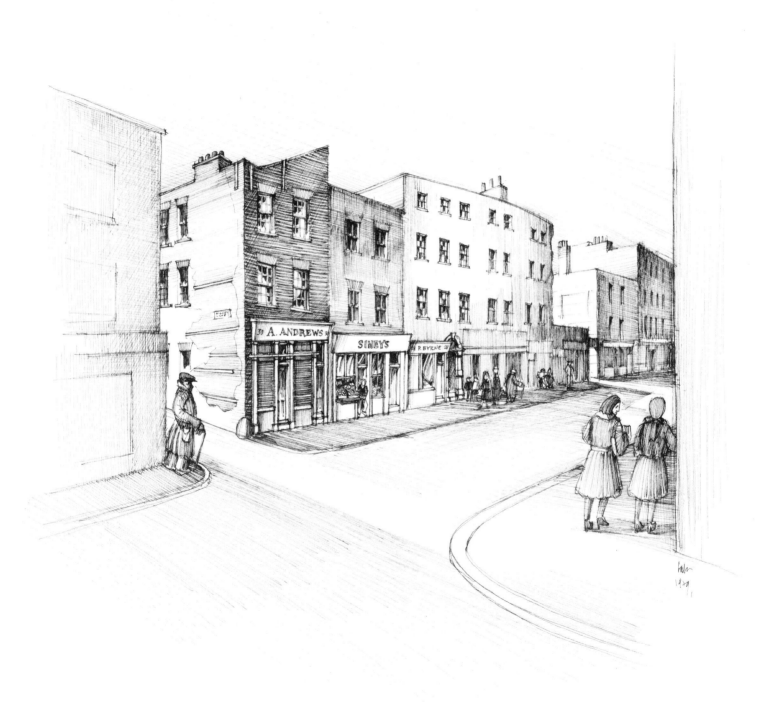

50 Lower Stephen Street

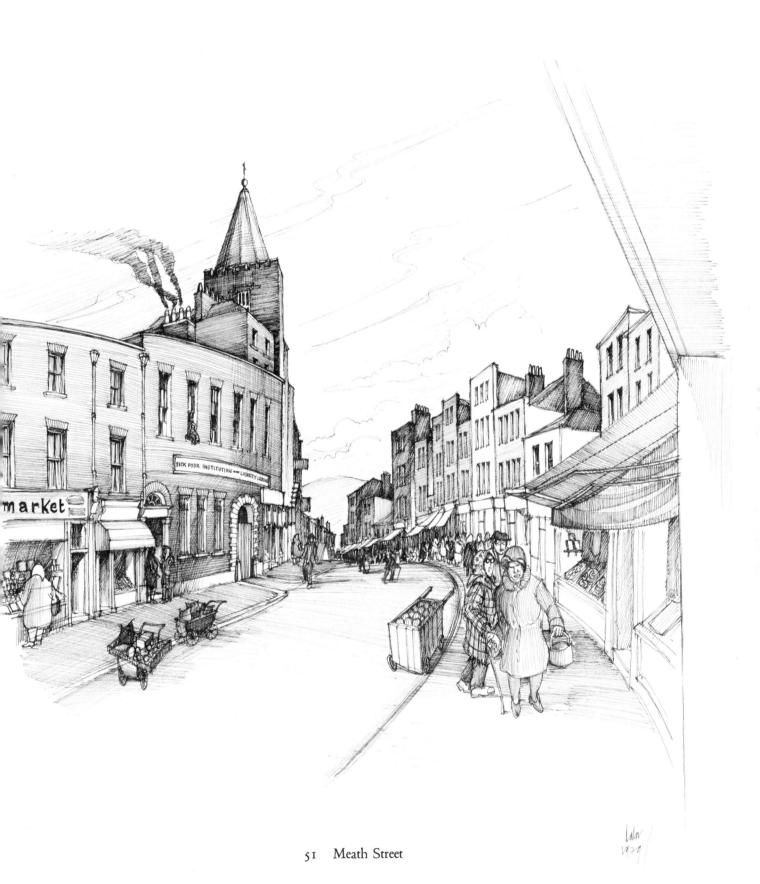

51 Meath Street

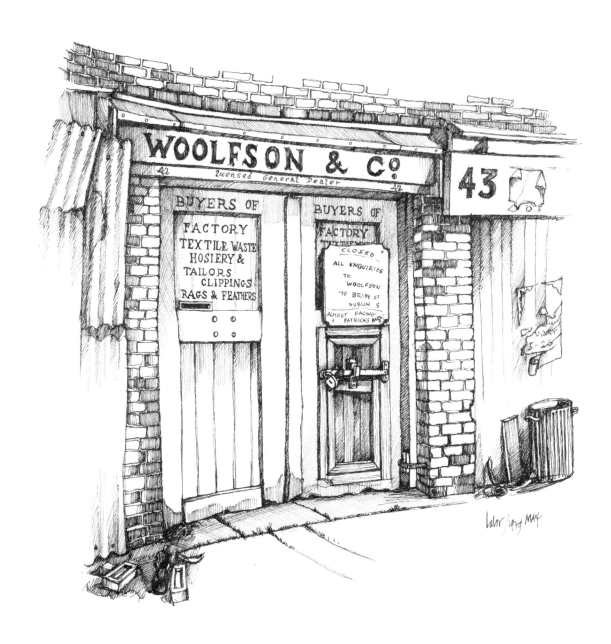

52 Kevin Street, Upper

53 North Great George's Street

BELIEF

54 O'Connell Street

BELIEF

A
REMARKABLE PROOFE FOR
EVER, OF CODS REVENGE *
IN HIS IVST IVDGEMENT *
VPON THE IRISH REBLLS *
BEING ON THE 2ᴰ DAY *
OF AVGVST 1649, THAT
OVR HO.ᴮˡᴱ COMAN = *
DERS AND SOVLDIERS
DID MAKE THE RE-*
BELLS NECKES TO *
COVCH VNTO TH = *
ERE SWORDS, FOR
WHICH FAMOVS
VICTORIE THE *
LORD CIVES VS
HEARTS TO BE
TRVELY
THANKFVLL
* · * · *
* · *
*

Manuscript relating to Cromwellian
Adventurers, 1649

This vengeful Deity, introduced into Ireland with the Reformation, has by the tenacity of His adherents, and the like determination of their opponents been the cause of much of the unrest and bigotry which has become one of the dominant features of local history for the succeeding centuries. The self-same righteousness which so fortified the Cromwellian Adventurers unfortunately still figures amongst the many facets of Belief in Ireland today. The curious development of Dublin's ecclesiastical architecture which allocated one century to the Protestants and another to the Catholics derives from the climate of the penal laws and an unhealthy enthusiasm for intolerance so powerfully expressed by this reverberating Biblical language.

Dublin's saints, like all Dubliners, reflect in their names their many origins — Michan, Werburgh, Aouden, and George; even Patrick evokes places far from the monastic life of early Christian Ireland. The growth in size and affluence of the city, communities and parishes is reflected in a continual development in church building. The dominant periods of its history are marked by particular developments of religious

fervour and this fervour expressed itself in the religious edifices which still dominate the city today. For Anglican and Roman Catholic as well as for Huguenot, Presbyterian, Methodist and Jew, Dublin has gathered together a collection of religious buildings unified by neither style nor scale, merely by purpose.

Street shrines are to be seen in profusion and in unlikely places, as in the midst of the traffic on a busy street or behind the railings of an eighteenth-century mansion. These little figures imprisoned in glass cages stand covered with dust and accompanied by some aged and dusty dead flowers or by more lurid plastic ones. Behind the fanlights, too, of many houses the broad cloak of the Infant of Prague or the slimmer figure of Jesus stand with their backs to the street, staring bleakly into the dark of hallways.

From the shrines behind the railings, strange metal tubes descend with pennies rattling down inside them into the sepulchral basement depths of the convents which occupy so many of the great mansions of the Irish nobility of the past. Posterity in fact must be grateful to these religious institutions which have become the tenants of many fine houses throughout the city. The fate of these buildings might otherwise have been that of a tenement declining into squalor and ultimate oblivion.

In many of the churches and graveyards throughout the city, memorial inscriptions can be seen to both the remembered and forgotten. In these inscriptions the piety and pomposity of the worshippers vie with each other for expression. Fine language too is found here, and occasionally an inscription of such striking honesty or fervour as to stand out from the banal formula and wishful sentiment. 'Gone Home' or 'Not dead but sleeping' characterize the language and thought of the latter.

The privileges of wealth have enabled those who in life would not have relished being part of the throng to be preserved from it also in death. In the private vaults of St Michan's, if one is lucky enough to have had one's forebears buried there, one can be entombed with them. Also there is the prospect of being naturally embalmed by the peculiar quality of the air in this remarkable crypt. Here the two opposing sides of the Irish political coin are seen, with the Shears brothers and Lord Leitrim still lying in state in the same corridor some yards from each other.

Due to the migrations of population and the disappearance of congregations many of the city's religious buildings have become defunct. Some are now only recorded in a plaque or a street name, to indicate the passing of some vanished or dispersed community, such as Protestant Row, Meeting House Lane, the Huguenot Graveyard in Merrion Row, Rehovot Lane, or the Synagogue in St Mary's Abbey. All the communities which have contributed to making up the variegated complexion of Dublin have by their beliefs indelibly marked the consciousness and folklore of the city. The monuments that remain to commemorate communities gone through decline or merger still have much to say about the city and its people.

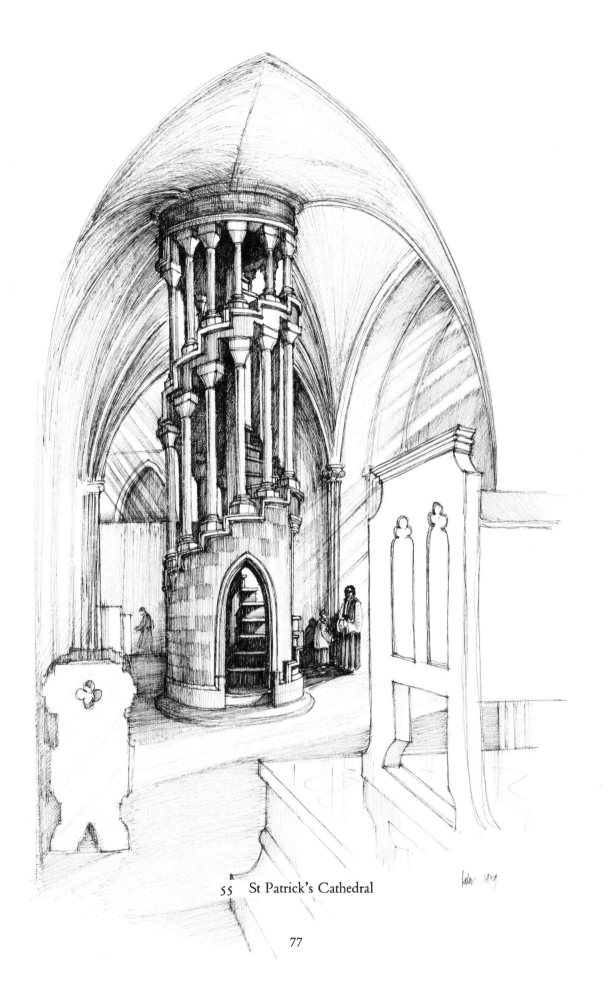

55 St Patrick's Cathedral

Religious beliefs expressing a particular theology and the prevailing architectural style of the time combine to determine what a building may look like. The eighteenth and nineteenth centuries in Dublin differ in respect of the former being a century of largely Protestant building and the latter largely of Catholic. The dividing line is not in fact so clear and a full stop cannot be placed at either the year 1800 nor 1900 for these activities. The Augustan age, with its strong concept of architectural style, paid less heed to theological criteria than to aesthetic ones in the formation of its religious buildings.

The great eighteenth-century city churches – St Catherine's, Thomas Street, St George's, Hardwicke Place, and St Werburgh's, Werburgh Street – display a unity of approach much less evident in the succeeding century. These churches have an overall relationship despite being separate and imaginative essays in the style of the time. In the nineteenth century more churches appear which, like St Aouden's and St Nicholas of Myra, are in the prevailing tradition of the great religious buildings of the previous century, but also a break occurs with this tradition.

The introduction of the Gothic Revival spirit with such a dominant masterpiece as the Church of SS Augustine and John perched on the western end of the hill of Dublin brought to an end the prevailing style of the previous 200 years. The myriad side roofs, great roof over the nave and towering spire seen from the river have a truly medieval air; not quite medieval perhaps, too ordered, but at least the Gothic spirit seen from the safe and saner distance of the latter end of the Age of Reason. It contrasts strongly with the massive bulk of the Catholic St Aouden's seen from very much the same area. This church, with its huge blank walls and blind arches of brickwork, has the grim severity of the ruins of the Augustan palaces on the hills of Rome and in fact has the makings of a splendid romantic ruin.

An interesting aspect of the Catholic St Aoudens is its relationship to its older neighbour, the Church of Ireland St Aouden, on which it virtually stands, and to which it turns its blind side, ignoring its Protesting predecessor.

On the south side of Stephen's Green, and completely concealed from the street except for a small porch of ornate brickwork, is one of the city's finest and smallest churches. This is the modestly scaled but exceptionally beautiful Newman University Church. This extraordinary building, more akin to the setting in a pre-Raphaelite painting than that of Irish religious practice, completely breaks with the style and austerity of the buildings of all denominations. It is a joyous expression of belief and belongs to a world in which Reformation and counter-Reformation have not occurred.

In St Patrick's Cathedral, one of the oldest of Dublin's churches, and itself a fine example of the great tradition of religious expression in the Middle Ages, we also find the last flourishings of the Gothic Revival spirit in Dublin. In the gloom of the North Apse, away from the soaring lightness of the nave, is an openwork spiral staircase leading to the

56 Emmet Street

organ loft. Built in the early years of this century it fits in happily with the rest of the building constructed a thousand years before.

Little now remains of the relationship between clergy and people which brought about the building all over Europe of the great medieval cathedrals. St Patrick's, like many other such buildings, is now orphaned, surrounded by factories and offices and not the densely packed dwelling areas which gave them their original purpose.

The relevance of religious belief to the history of Dublin is immense and lasting. The factions and bigotry of the past which gave rise to much animosity are if not entirely vanished, at least less of a force in the life of the city, and with the passing of such antagonisms, the memory of past outrage and ancient righteousness should become no more than historical facts, safely entombed in books.

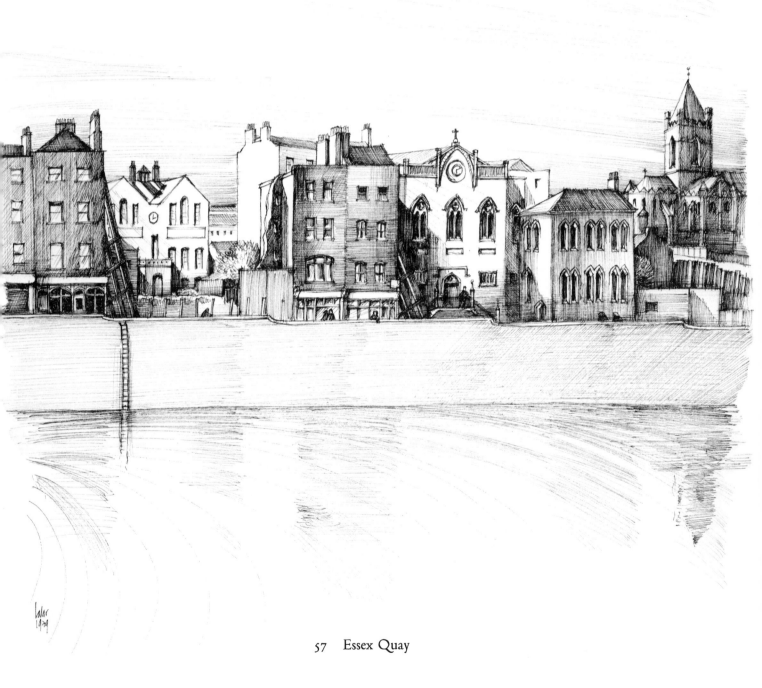

57 Essex Quay

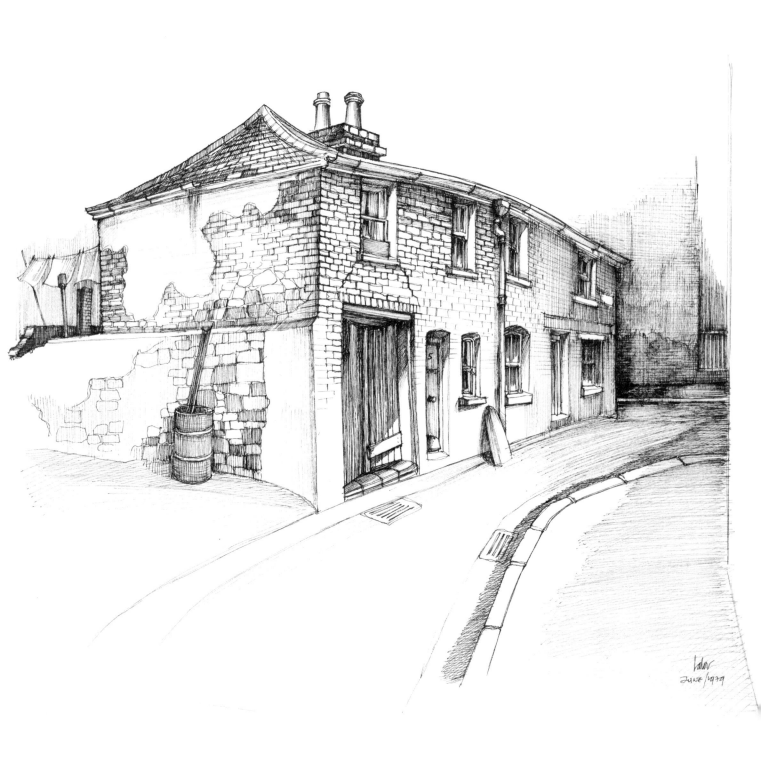

58 Protestant Row

59 Fairview Strand

60 St Michan's Church

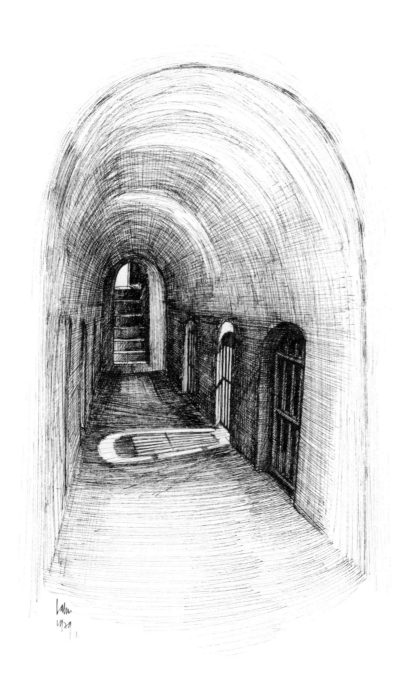

61 St Michan's Church

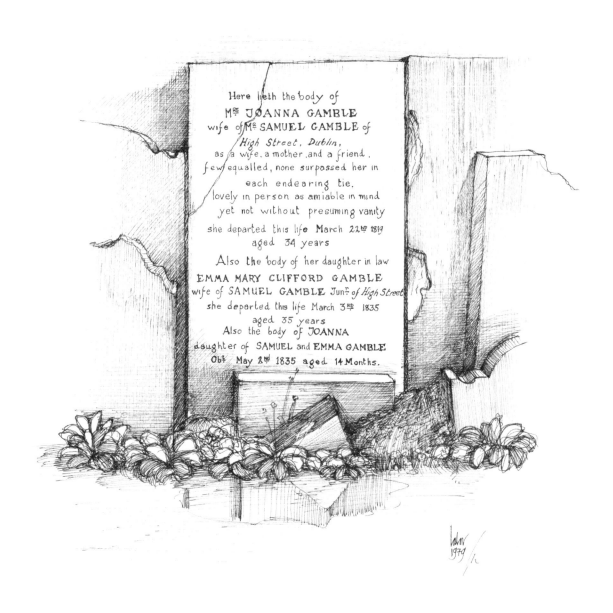

Here lieth the body of
Mrs JOANNA GAMBLE
wife of Mr SAMUEL GAMBLE of
High Street, Dublin,
as a wife, a mother, and a friend,
few equalled, none surpassed her in
each endearing tie,
lovely in person as amiable in mind
yet not without presuming vanity
she departed this life March 22nd 1819
aged 34 years

Also the body of her daughter in law
EMMA MARY CLIFFORD GAMBLE
wife of SAMUEL GAMBLE Junr of High Street
she departed this life March 3rd 1835
aged 35 years
Also the body of JOANNA
daughter of SAMUEL and EMMA GAMBLE
Obt May 2nd 1835 aged 14 Months.

62 St Peter's Church, Aungier Street

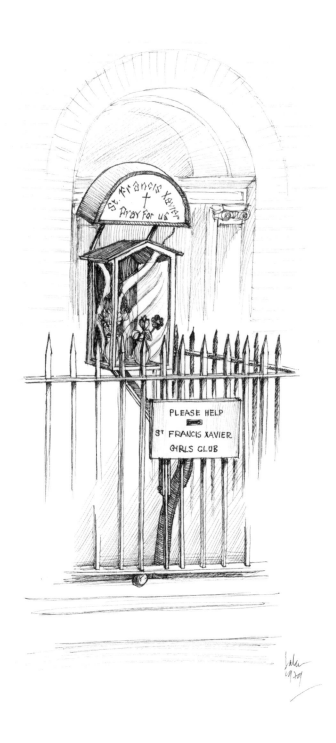

63 Gardiner Place

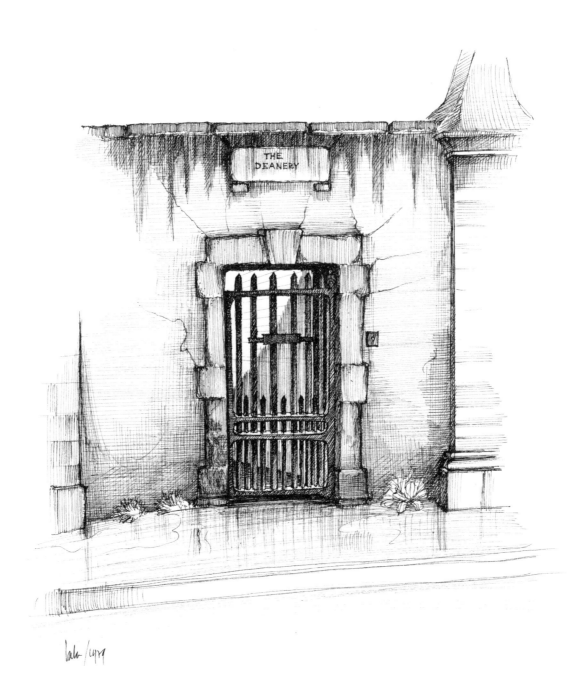

THE
DEANERY

64 Kevin Street

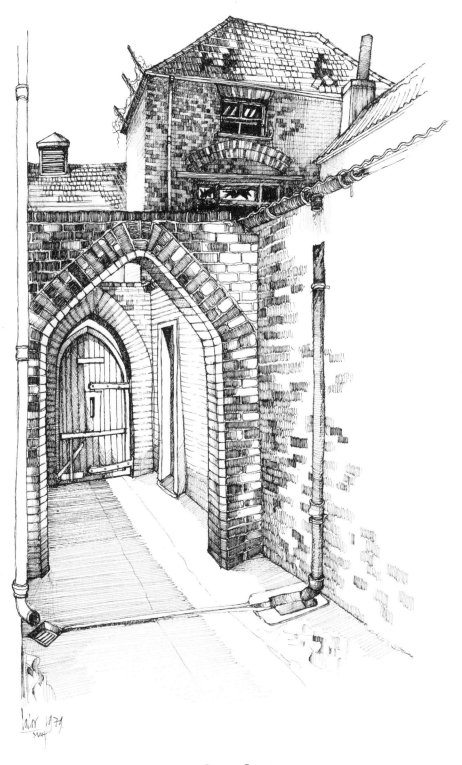

65 Pearse Street

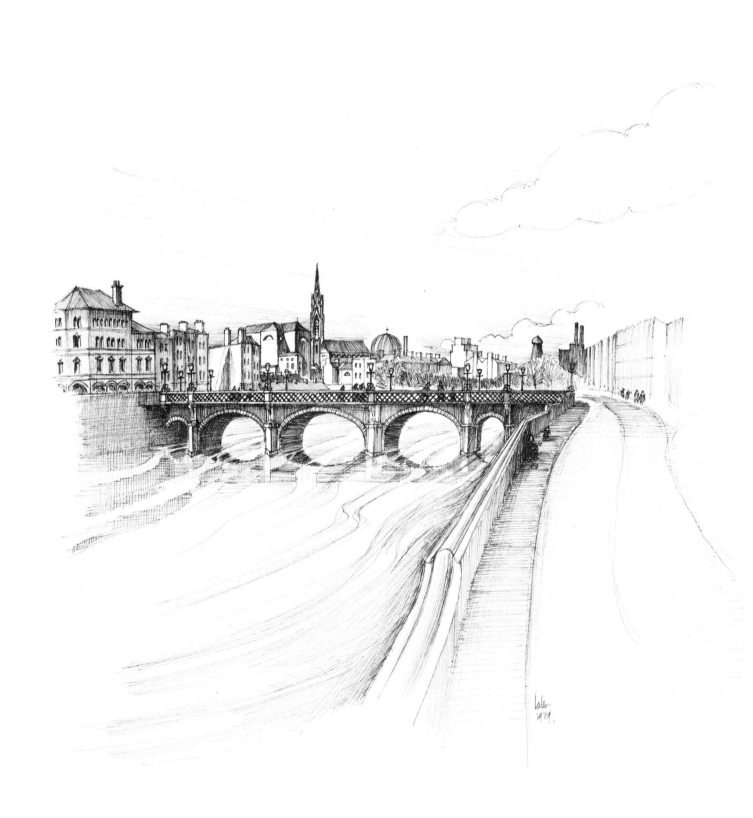

66 Grattan Bridge

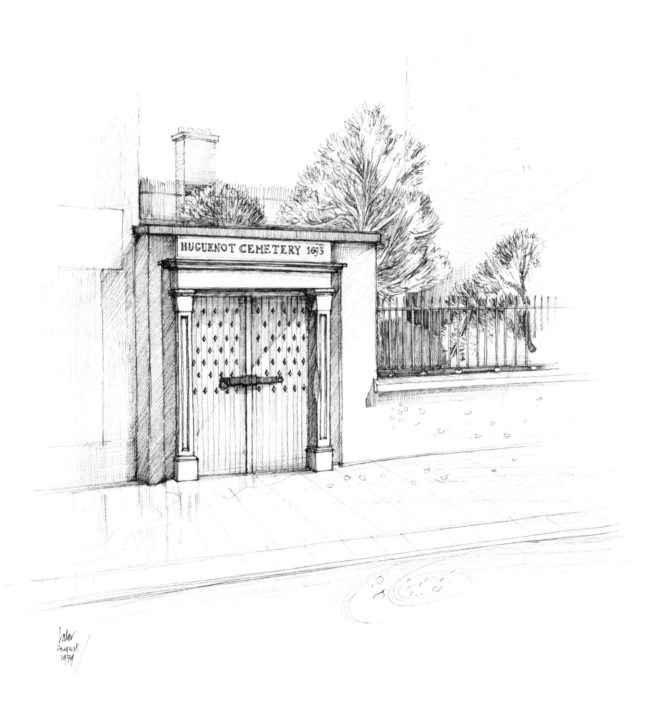

The drawing's sign reads: HUGUENOT CEMETERY 1693

67 Merrion Row

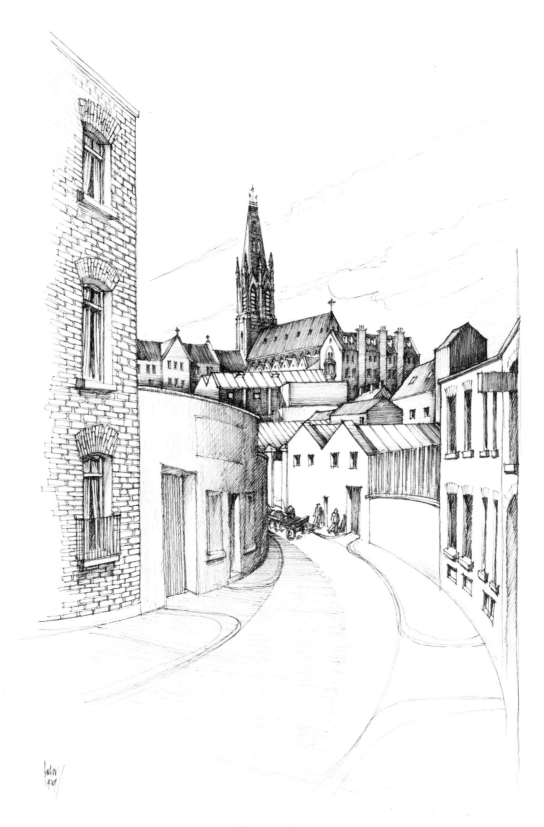

68 Thomas Street

69 Parnell Square

THE MEDIEVAL CITY

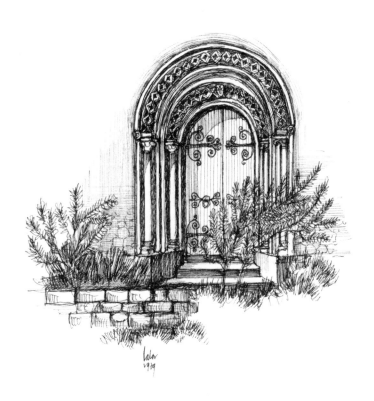

70 Christ Church Cathedral

THE MEDIEVAL
CITY

ᢞᢣᢞ

This City, as it is not in antiquitie inferiour to
anie citie in Ireland, so in pleasant situation, in
georgious buildings, in the multitude of people, in
martial chivalrie . . . it is superior to all other cities
and townes in that realme.

Richard Stanyhurst,
From *Hollinshed's Chronicles*, 1577

The cities of the medieval world tended to be small by comparison with those that
preceded them in Classical times. Contractions of mind and body produced the teeming
life on a reliquary rather than the breadth of the Colosseum, small, walled enclosures
crammed with precariously built houses, narrow winding streets full of offal and general
urban refuse; in all, not the most attractive places to live, stinking, unsanitary, and
overcrowded. Yet out of these unpromising surroundings of wooden houses and unpaved
roadways arose some of the greatest physical proofs of man's spiritual aspirations that have
ever been known.

From this squalor and inward-lookingness came the magnificent Gothic cathedrals
that today throughout Europe are treasure houses of art and beautiful expressions of the
medieval mind. Stone carving, stained glass, and superlative skill in engineering are the
hallmarks of these buildings. Not since the great dome of the Hagia Sophia was cast across
the sky of Constantinople 600 years before had the human imagination harnessed human
skills to such splendid effect. Some of these extraordinary churches took a century to
build, an unimaginable maintenance of enthusiasm to the man and mind of today.

Medieval Dublin, from its Viking foundation in the ninth century to the
Reformation in the sixteenth was no exception to the state of things elsewhere: a walled
acropolis with its citadel safely perched on the high ground of the Liffey's southern bank
and protected from flood waters by the rising land and from enemies without by a stone
wall and many towers. The original wattled dwellings and wooden walls eventually gave
way to more substantial structures of stone.

Within the safety of these walls much could be attempted, and church building
flourished. Amongst the many towers of the medieval parish churches two dominated by
their size and importance: the Cathedrals of Christ Church and St Patrick. Christ Church

Cathedral, the earlier, and within the original walls at the very centre of the old city, is also the smaller of the two. To the south, and attached to the Palace of St Sepulchre, was St Patrick's Cathedral. The Cathedral still stands, although the Palace has all but disappeared. This great building, like Christ Church, has been much altered and restored, yet the ideas and craft which gave it birth can still be appreciated in what has survived.

The civil and religious institutions of medieval Dublin, which were still visible well into the seventeenth century, became submerged in the growth of the eighteenth century. Now, with the exception of the cathedrals, and a few other scattered remnants, these institutions have been demolished, excepting what may be concealed below ground level. Straddling the hill between the rivers Liffey and Poddle, the original settlement grew within the walls and later, expanding outside them in the twelfth century, began to develop into the skeleton of today's city.

Unlike the building material for which Dublin is now known (a beautiful mellow brickwork), the early city was one of very different colour. In its walls and principal buildings at least from late medieval times onwards it was a city of stone. The mottled remains of the city walls and churches give one an idea of the scale and texture of such a city.

The characteristically severe lines of Dublin's medieval cathedral and church towers still dominate the skyline, mixed as they are with later conceptions of church buildings. Many of the medieval foundations have survived in some form into the present day or have been replaced by later buildings of the same dedication.

Although the modern streets have been widened and are steadily losing their relationship to their medieval orientation, the general pattern of the area between the Liffey and St Patrick's is one of an unplanned rambling city of the late middle ages. The names of the streets, too, recall their remote origins – High Street on the brow of the hill; Fishamble Street, the fish markets; Ship Street, the sheep markets – and many other such associations.

Looking from the tower of St Michan's Church on the north side of the river and across Father Mathew Bridge, the site of the original and, for centuries, only bridge over the Liffey, the city as it may have appeared in medieval times can still be imagined. It stretches from the western extremities of the hill of Dublin with the tower of St Catherine's Church, to the distinctive steeply pitched pyramidal roofs of St Michael's Church and the Cathedral of Christ Church on the eastern side. Between these points on the horizon and the great spire of St Patrick's Cathedral to the south lies the body of the city prior to its sudden expansions in the age of affluence.

On the south side of Christ Church Cathedral can be seen the remains of its chapter house and still standing southern wall of the apse with its beautiful Hiberno-

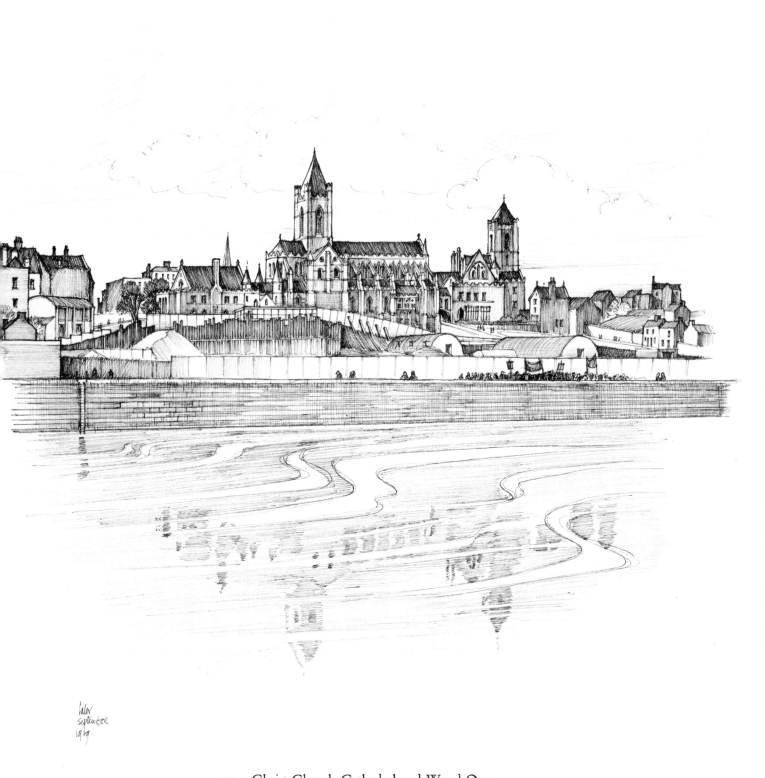

71 Christ Church Cathedral and Wood Quay

99

Romanesque doorway. This is the earliest link with the art of the past which can be conveniently seen in the city. Inside the Cathedral is the twelfth-century crypt, a dark and sepulchral area below the building with huge rough piers and arches. St Patrick's Cathedral, being built on the banks of the River Poddle, has no crypt.

Across the river, and even more hidden from the street, lies the Chapter House of St Mary's Abbey in Meeting House Lane. This small room with its groined vaulting is all that remains standing of Dublin's many supressed monastic foundations. A fine prospect of the towers of St Michael's and Christ Church with the spire of St Patrick's in the background can be seen from the north side of the river. With the small dwelling houses, lanes and alleyways which still cluster on the area to the west and must have originally occupied all the space between the churches and the river, one can appreciate the striking impression which must have been felt when coming up the Liffey, Dublin's principal thoroughfare between the twelfth and sixteenth centuries. The relationship of church and river, so long concealed by large buildings of the intervening centuries and seen now in all its magnificence, is soon to disappear behind the ill-sited mass of the Corporation offices.

For a more intimate access to the medieval city a walk around the perimeter of the city wall, where it can be seen, is the most tangible evidence of its size and character. The gate of St Aouden's beneath the tower of St Aouden's Church and with the city wall of the twelfth century on either side brings one closest to the scale of the time. For restoration to be meaningful it must depend on the depth of what one both knows and understands of the cultures of the past. The appearance of this fragment of the city wall is doubly confusing as it has been twice restored by conservators, first in the nineteenth century in the Gothic Revivalist style of the time and the second time more recently in a style owing more to the suburban villa than to any known historical period.

Much of the Dublin of the Middle Ages lies preserved and concealed beneath the streets. The wealth of findings at Wood Quay proves this beyond dispute. The tragic loss of these findings in the interests of a perverse philistinism should not be forgotten. Dublin is not so well endowed with an abundance of relics of its history that these can be carelessly concreted over or demolished at the whim of a planner. Such fragments of a nation's past must be preserved in order to make that past tangible for generations to come.

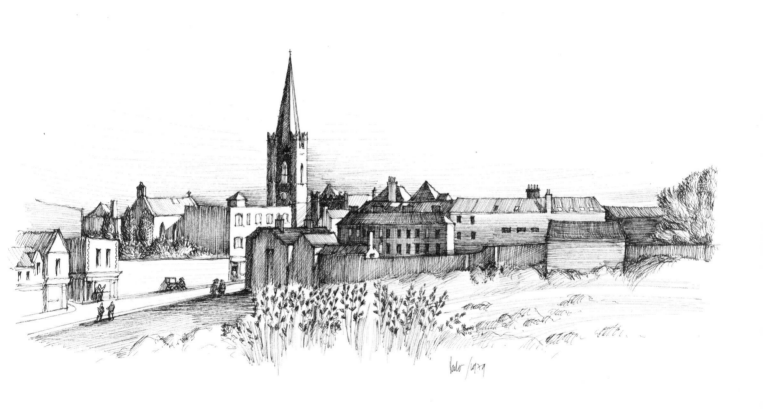

72 St Patrick's Cathedral

73 St Mary's Abbey, Meeting House Lane

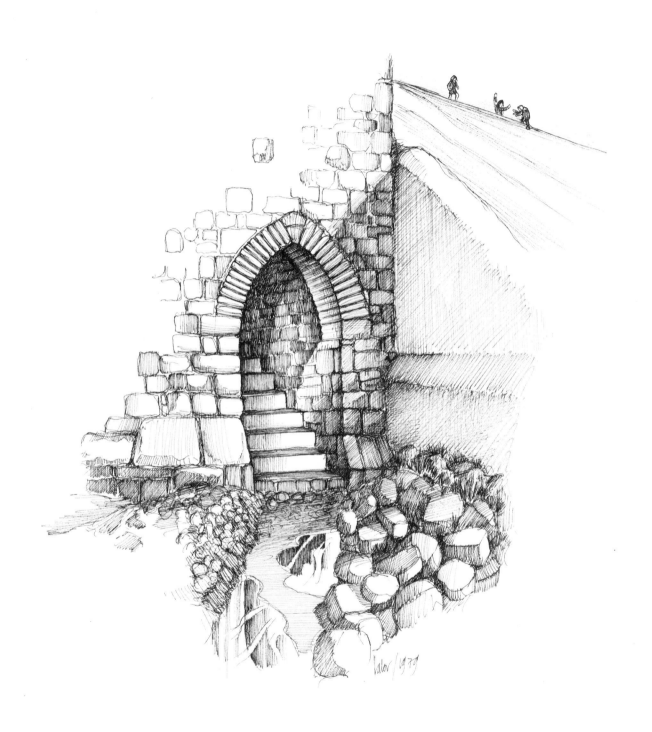

74 Cook Street

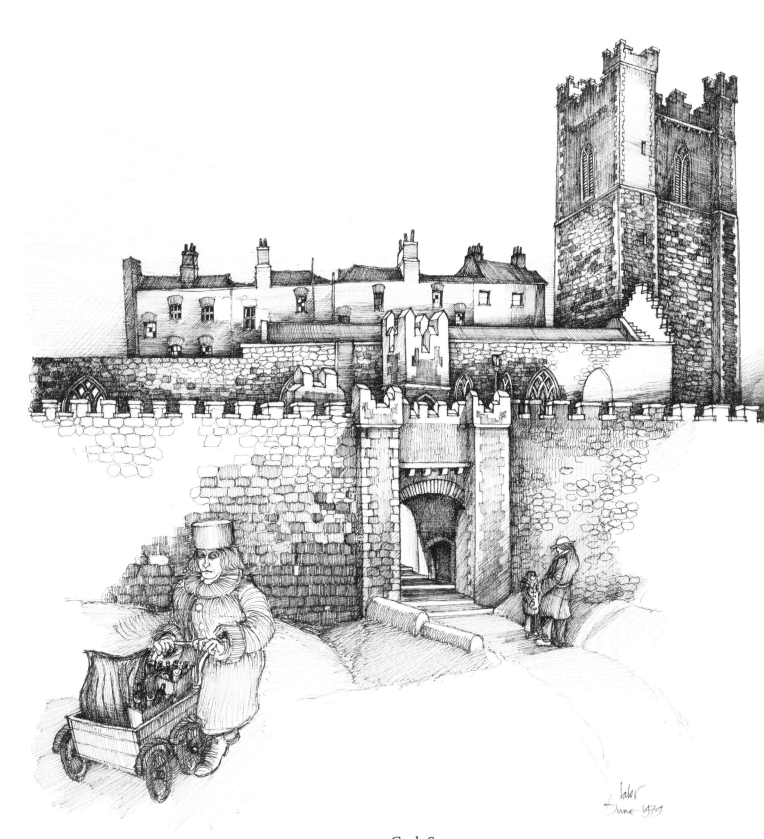

75 Cook Street

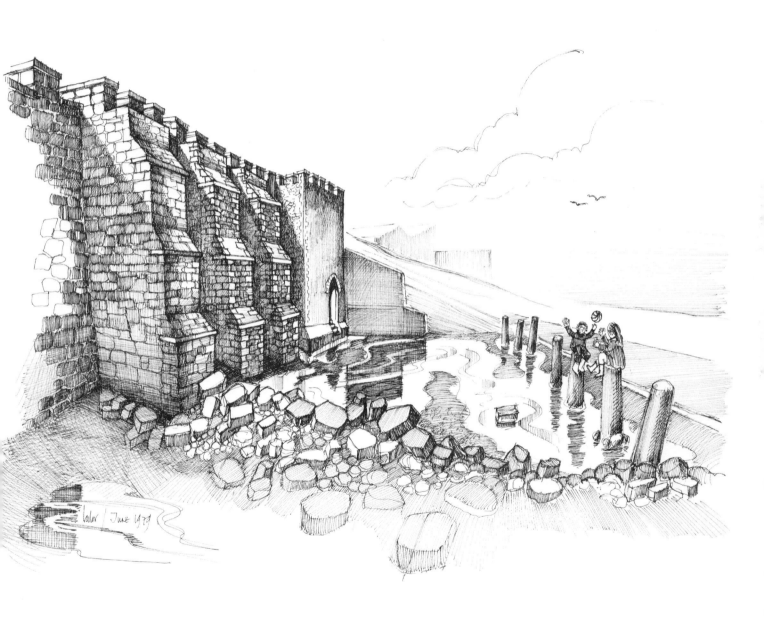

76 Cook Street

77 Thundercut Alley

CASTLE
AND CROWN

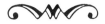

78 Kilmainham Prison

CASTLE
AND CROWN

꙳

The vilest deeds like poison weeds
Bloom well in prison⁄air:
It is only what is good in Man
That wastes and withers there:
Pale Anguish keeps the heavy gate,
And the Warder is Despair.

C.3.3.*(Oscar Wilde),
'The Ballad of Reading Gaol'. 1899

There is little unity in Dublin's crop of ecclesiastical buildings, representing as they do differing ages, temperaments, theologies, and also purses of vastly varying size. Residential areas present a more unified front, despite the demands of different classes and times, and a beginning, growth, zenith and period of decline are all to be clearly seen within that unity.

The single group of Dublin's buildings which form an absolutely cohesive body are those institutions of the state dating from the latter years of the eighteenth century and early years of the nineteenth. These buildings are mainly concerned with law and its instruments. These various arms and tentacles of the British Crown which bound rural Ireland to Dublin, and Dublin to London, have a grand and infamous history in the many shifts of emphasis between justice and oppression.

Jails and courts form the heart of this grouping and are scattered all around the city. They are great stern edifices of cut stone, the characteristic and humanizing Dublin building material of coloured brickwork is nowhere seen. Many of the most notorious of Dublin's jails are now gone, and those that remain are by comparison the products of a more enlightened understanding than that which produced their predecessors.

Mountjoy and Kilmainham alone remain of the many that once cast their dark shadows on the city. Of these two, only Mountjoy is used as a jail today. Kilmainham was the principal prison for political offenders between 1798 and 1922 when it was abandoned, a hopeful though unfulfilled gesture. The long and revered litany of the names of the Irish Pantheon of Heroes that were imprisoned here includes most of the relevant figures from over a century of turmoil and agitation.

*'The Ballad of Reading Gaol' was originally published without the poet's name, his number as a convict in Reading Gaol being substituted on the title page. C.3.3. indicates block C, third cell, third floor.

Entering Kilmainham from the street through a heavily grilled gate, one passes beneath a remarkable panel of symbolic bas-relief in the tympanum of the doorway. This panel leaves little mystery as to the purposes of the building and no doubt was intended to assure the upright citizen as much as to quell the spirits of those about to be incarcerated. Depicted are a group of enraged and squirming serpents heavily chained. So evident is the misery of these villainous-looking and unfortunate beasts that one can practically hear them hissing and protesting their imprisonment. Among the many Irish nationalist leaders who were imprisoned here, few do justice to such an image of the frenzied anarchist – hardly the embodiment of Parnell or Emmet. It is a rare piece of sculpture in which the artist seems to be aware both of the danger of criminals to society and, conversely, the danger to the criminal of incarceration. But perhaps this is hindsight?

Inside Kilmainham the vast central area with its glazed vault and cast-iron companion ways is a fortunate survivor, now restored after sixty years of abandonment. The labyrinthine corridors which lead off the central area contain the cells of many who were subsequently to die on the gallows or by firing squad either in the prison yards or in the public streets.

Mountjoy, on the banks of the Royal Canal, with its towers and forbidding enclosures wall, dominates that area of the north of city. It is no less grim for being the product of less medieval ideas of prison design.

The central core of the establishment of law and power in Dublin from its foundations has been the Castle. Built on the highest part of ground south of the Liffey and originally moated on two sides, it retains two of the towers of its original fortifications. The line of the city wall to the south runs between these towers and off to the west over the brow of the hill in fragments, and curves down towards the river. The Castle, representative seat of civil and military power in Ireland, has a value that is symbolic as well as actual. The physical changes it has undergone seem to conceal its character as citadel and fortress and let its more benign aspect as the scene of Viceregal receptions dominate today. A circuit of the Castle with its gates and steps, towers and intimidating blank walls, is the best reminder of what this enclosure symbolized for centuries. The outline of the buildings of the Castle, which, with Christ Church, must have dominated the landscape, has been totally obscured by the surrounding buildings and rendered insignificant in its visual impact on the city of today.

Blocking the vista at the top of Henrietta Street with its convents and palatial tenements is one of the most individual of the city's legal buildings, and a fine exercise of imaginative design, the King's Inns. The combination of the almost Florentine severity of the palaces with the Inns produces a relationship uncharacteristic of the juxtaposing of public and private edifices in the city. The feeling of enclosures and dignity achieved here in the small forecourt, with the curiously fenestrated blocks of the building rising to the

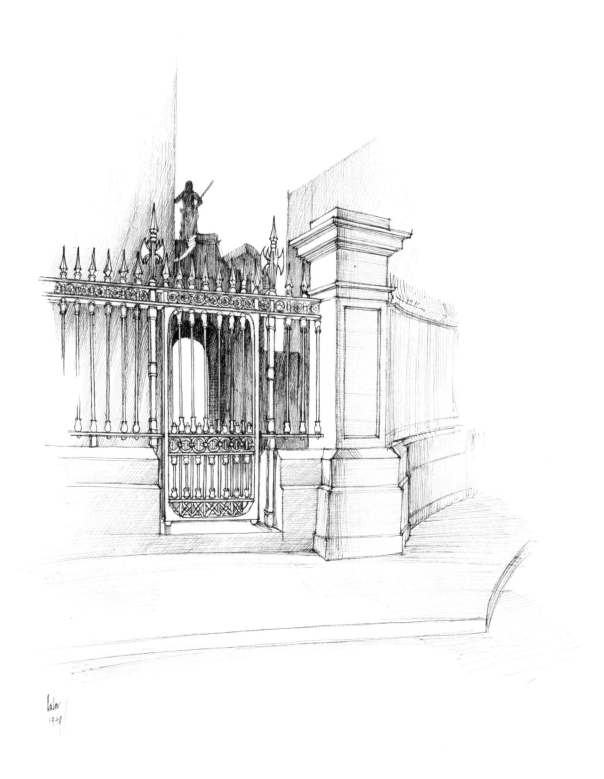

79 Cork Hill

ornamental oval windows at the top, is a rare example of true originality in the architecture of the Classic revival.

The passing of the British administration and half a century of native government have added nothing to this group of Dublin's legal buildings. Tawdry and bland extensions to the Castle state little about the age, beyond the ever-present need for increasing office space.

The Royal Hospital at Kilmainham, antedating these buildings by a good hundred years, was built to house the soldiers of disbanded armies – the relics of the campaigns of the Williamite Wars. In the courtyard of this enormous building is the bronze statue of Victoria which once stood in the forecourt of Leinster House. Here, incarcerated in the company of the ghosts of her armies, she sits with her ample Britannic breast decked with stars, awaiting the Imperial Second Coming.

80 Kilmainham Prison

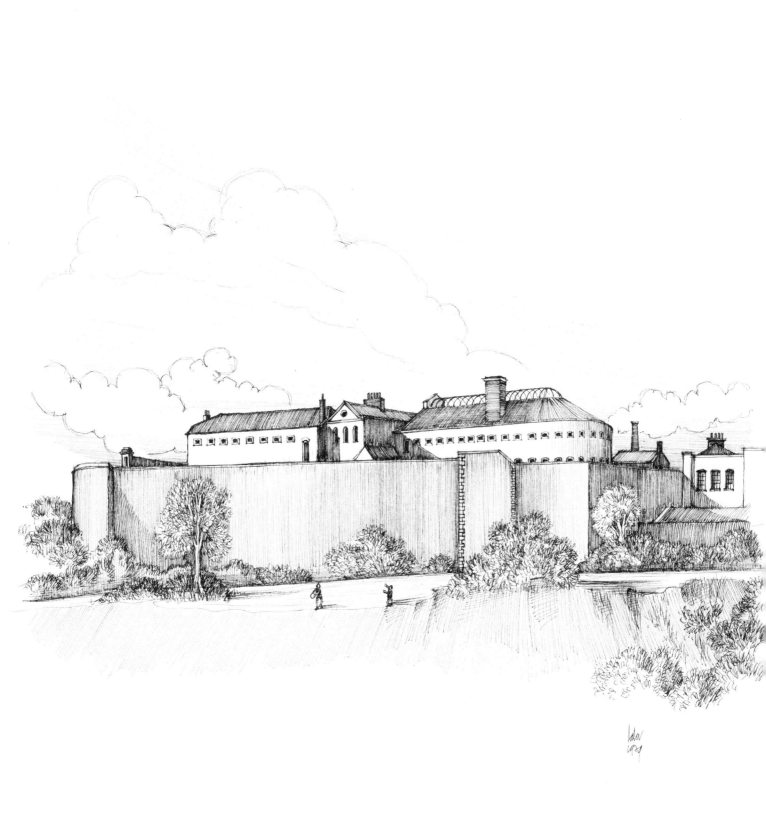

81　Kilmainham Prison

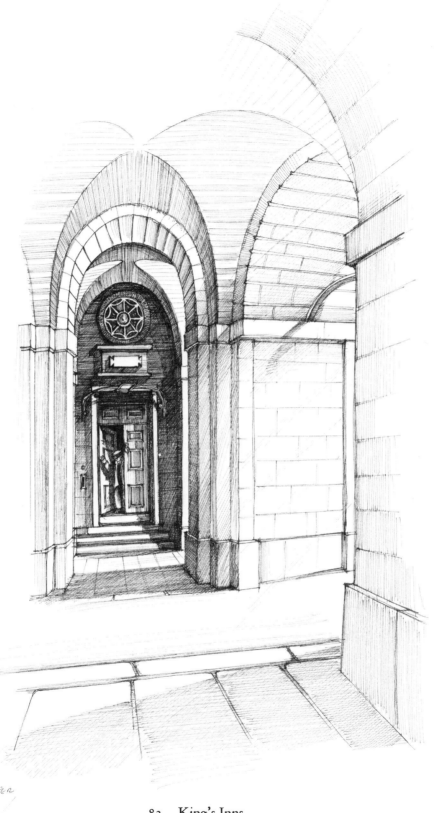

82 King's Inns

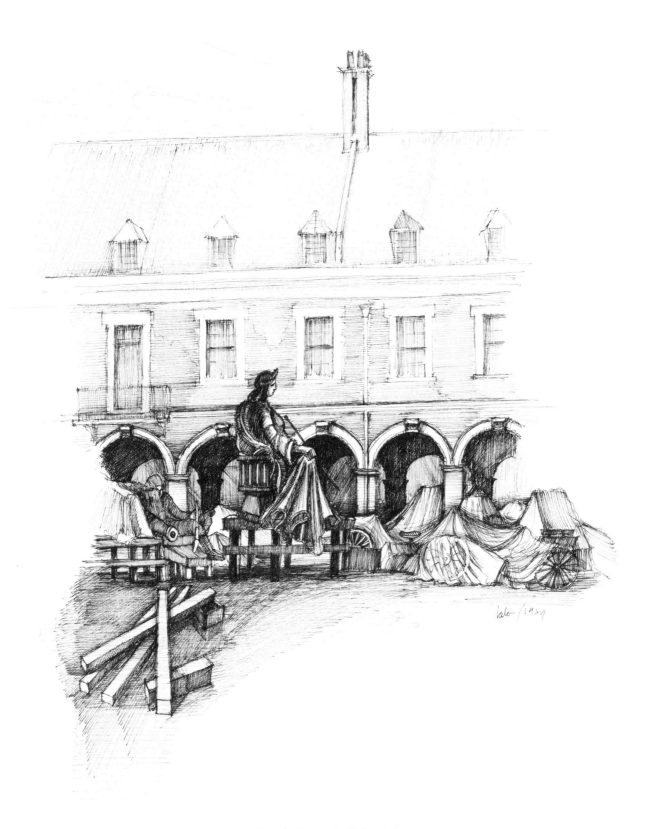

83 Royal Hospital, Kilmainham

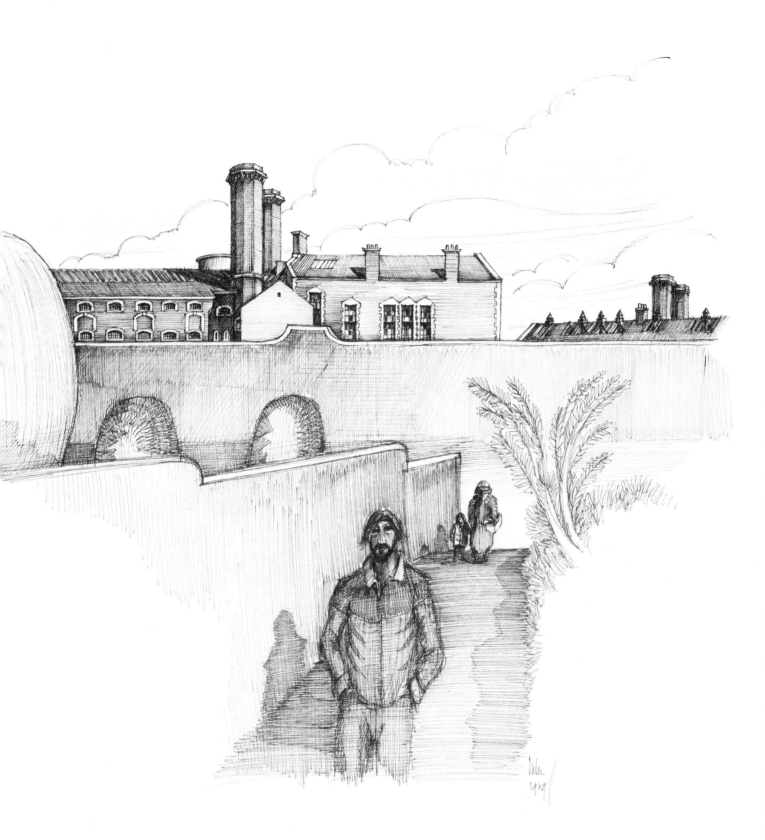

84 Mountjoy Jail

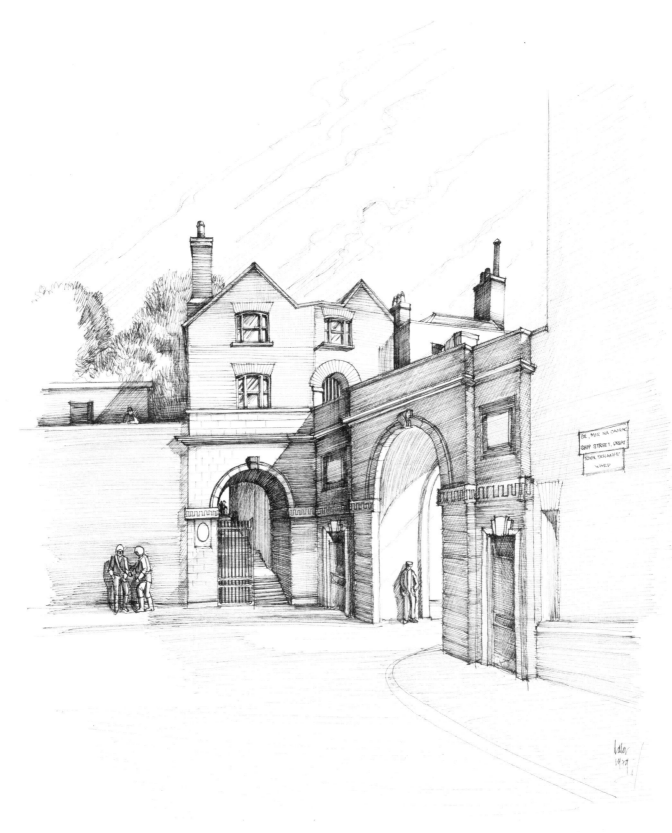

85 Ship Street

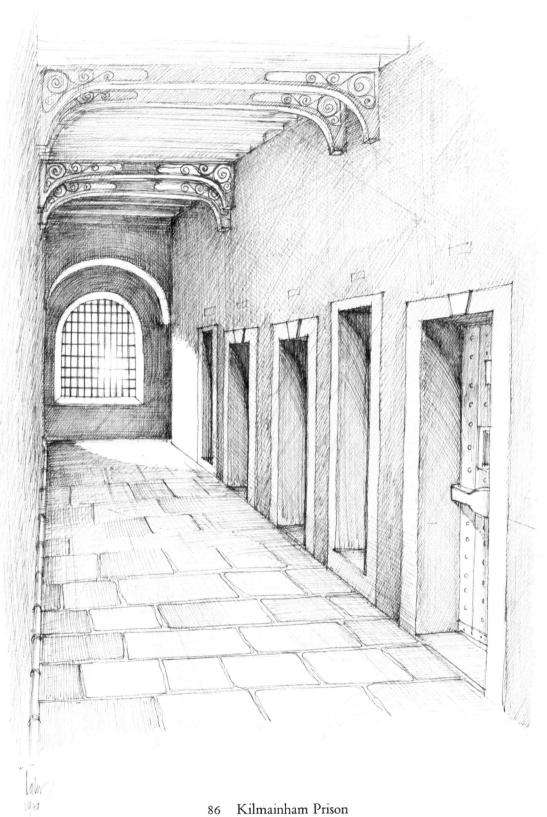

86 Kilmainham Prison

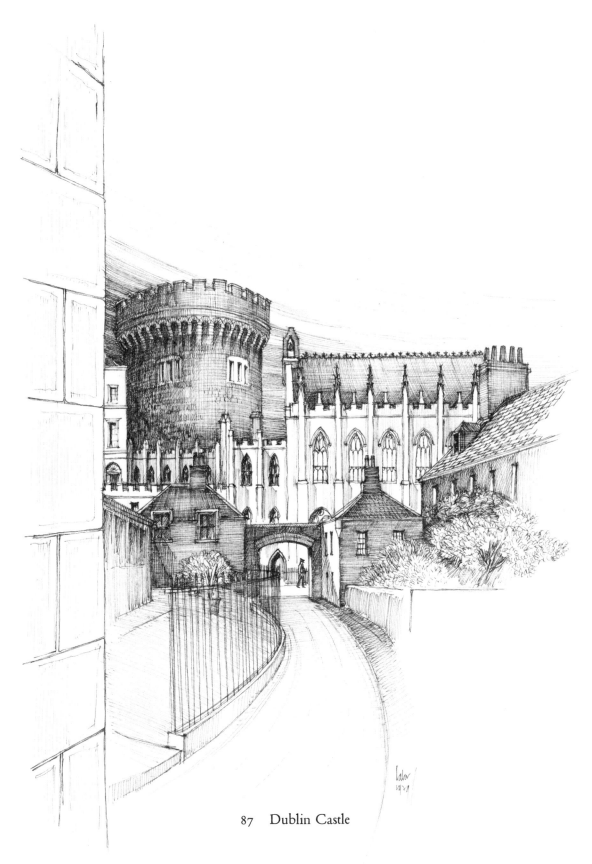

87 Dublin Castle

CONCLUSION

88 Summer Row

CONCLUSION

The real and principal *theme* of Dublin is of course its people. The buildings, the monuments, the relics, holy and profane, are merely the shadows of the real substance. The dead should never be more real than the living. The buildings and streets provide the backdrop, the stage setting for the action. With time and handling these become as alive and as human as those who lived in their midst. This humanity is passed on by the surroundings and the people are humanized again in consequence by the environment.

Standing one day in Cook Street while drawing the medieval City Wall, I was approached by an ancient women pushing a vehicle, half pram-half barrow, filled with bottles and what appeared to be equally ancient cabbages. After the ritual questioning as to what I was doing and why, she pronounced her verdict, with a sweep of her arm which seemed to suggest the whole world rather than just central Dublin: 'The Corpo have the whole city obspliterated.' Later on in the same day I had moved towards Christ Church, some few hundred yards to the east, and was preparing a draft of a drawing of the Cathedral. A passing lorry driver shouted at me as he raced up the hill. 'You'd want to hurry, mister. They're knocking it down next week!'

Not all my encounters, however, were on this sombre and grimly prophetic level. The weather, for which not even the Dublin Corporation might be blamed, was a continual obstacle to the pursuit of my work. Many drawings were only completed after a succession of visits to the particular location. This necessitated much standing in doorways conversing with passersby and explaining my purpose to the interested, inquisitive and the suspicious. On one such damp occasion, I even met a man who *knew* Bloom!

This occurred in Eccles Street outside No. 7, which was used by Joyce in *Ulysses* as the house in which Bloom lived. An elderly man in a dark suit and flat cap passed and commented, 'You are drawing Bloom's house, I see.'

'Yes.'

'I knew him well, poor Bloom.'

'I beg your pardon?' (Halting in scratching on my pad.)

'Bloom of course, an old friend.'

'Do you mean Joyce?'

'No, Bloom, Leopold Bloom, lived in this house with his missus.'

'But you couldn't have known him. He is only a character in Joyce's book.'

'Is it Bloom? Sure didn't I borrow his bicycle many's the time?'

'You must be mistaken.' (All scratching now stopped at this piece of indisputable evidence.)

'Sure I knew his mother, Old Mrs B. A lady of the old sort.'

This conversation is not apocryphal, perhaps he *did* know Bloom, I can offer no explanation, but Bloom would have been a very old man indeed, and then of course there is the question of the mother!

Working on the Panoramic View of Dublin was primarily a battle with the elements. Between the parapet and the pyramidal roof of the tower of St Michan's is a narrow walkway wide enough for one person to stand in discomfort. At this height and in the face of very severe gales I proceeded to do my drawing. As a picture of this nature requires considerable precision and concentration, little more than an hour's work at a time was possible, in consequence of which, I spent some weeks going up and down the spiral staircase, hoping that the weather, fine when I entered the church, would not be raining when I got to the top of the tower. The remarkable prospect from the top of the tower presents an unfamiliar view of Dublin. The view to the south (which I have drawn) has all of the city's history lying before you compacted into a prospect of great intensity. To the north and west lies a likewise unfamiliar angle on familiar objects. However, to the east, looking down river, the view has familiarity of a very different kind. Was it the waterfront in Hong Kong or the skyline of Tel Aviv? In this quadrant the great changes in the city's development of the past ten years have all suddenly been grouped together. The result is not exactly a distinguished prospect.

On descending one day from the tower with a largely completed drawing, I entered a shop nearby and getting into conversation, the drawing was produced. The reaction was not quite what I had anticipated. From the woman behind the counter in a very forthright manner came the remark, 'Any man that would draw roofs is a *fool*.' A customer, however, presented the greatest difficulty. She could not grasp why one could not also see the faces of the buildings as well as the roofs, and thought me lacking to have ignored such a consideration. The Cubists would have warmed to such an apt disciple.

In the period which has elapsed since beginning this collection of drawings much of what was drawn is now gone. For an artist to see what he has drawn or painted disappear is a painful experience. When a building or street scene actually vanishes before one's eyes while in the course of being drawn this is particularly violent. It is as if for a portrait painter the sitter were to be murdered half-way through the session in an extremely brutal manner and before the artist's eyes. It was my experience on a number of occasions to have to work with speed as the sitter was being demolished while I drew. Whether this violence is done in broad daylight or at night, when the city lies 'like a patient etherised upon a table', matters little. The latter crime is more insidious.

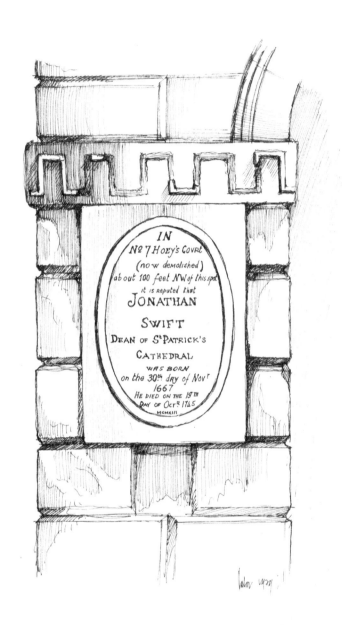

IN
Nº 7 HOEY'S COURT
(now demolished)
about 100 feet NW of this spot
it is reputed that
JONATHAN
SWIFT
DEAN OF St PATRICK'S
CATHEDRAL
WAS BORN
on the 30th day of Novr
1667
HE DIED ON THE 19TH
DAY OF OCTR 1745
MCMXLIII

89 Ship Street

The good, however, can be glimpsed in corners, as though the barbarians within the forum have either withdrawn or became at length civilized by intermarriage with the inhabitants. Over half a century of neglect of the city and its fabric have created almost irreparable inroads into its cohesiveness. A tendency to identify the physical fabric of Ascendancy Dublin with its political viewpoint led to a national blindness to the virtues of the former in pursuit of the iniquities of the latter. The corrupt and sectarian administration which gave rise to much of the grandeur of Dublin at the time of the Union may not be a pleasant memory, yet that very grandeur and high-mindness, even if of limited perceptions in some ways, is some vindication of the more obvious laspses of the regime.

Now for the first time since the foundation of the state major projects are under way to restore and open to the public fine examples of the eighteenth-century architecture, such as Lord Charlemont's Casino at Marino, a diminutive Palladian masterpiece. This will be the first time that Dubliners and visitors alike will be able to appreciate what the interiors of the great houses of Dublin were like in their magnificent heyday.

Another positive sign is the rebuilding of such areas as the Coombe, not according to the disastrous principles of the pioneers of twentieth-century town planning, but in a manner that is primarily humanistic in approach. Gone (and hopefully for good) are the tower blocks, twenty-storey monuments to folly and illusory efficiency, and back has come the concept of living on the ground or not too far above it, with corner shops, neighbourhood shopping streets, interior courtyards, pleasing materials and trees.

For the pedestrian the relaxed oases of College Park, Merrion Square and Stephen's Green are what make the most aggressive aspects of city life tolerable. Little has happened in Dublin since the eighteenth century to contribute to the city's stock of such amenities. An optimistic note has now been sounded with the new Central Bank piazza on Dame Street. Despite misgivings about the Bank itself, its undoubted excellence at street level has made another threatened corner of the city suddenly take on new life.

We can hope in the future for something more than just a reprieve from execution for Dublin. The revival of the eternal values of urban dwelling which have hardly been improved on since man ceased to be a nomad and built towns is one major step. Another would be the abandonment of anaemic pastiche in coping with the very real problem of adapting an eighteenth-century residential city to modern business needs. Real restoration is the answer where it is possible and, where it is not warranted, good modern developments instead of the hopelessly bland and characterless Georgianesque compromises which have become common. John Ruskin in an essay on 'The Influence of Imagination in Architecture' says,

The very essence of style, properly so called, is that it should be practiced *for*

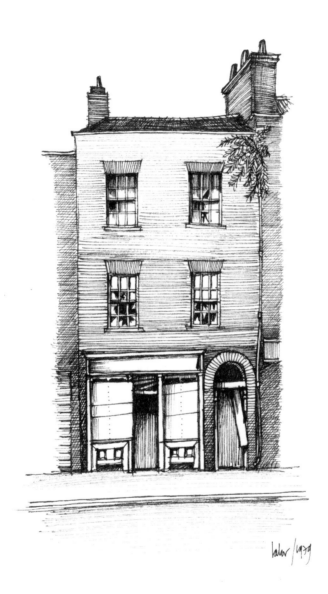

90 The Coombe

ages and applied to all purposes; and that so long as any given style is in practice, all that is left for individual imagination to accomplish must be within the scope of that style, not in the invention of a new one.

This was particularly true for Dublin over a long period and because of the fact that the style was 'applied to all purposes' the many gradual transitions which took place between the late seventeenth century and the early twentieth were painless ones. For the threads of this great skein to be caught up again and fresh ones woven in as happened so often in the past would be the best way forward, uniting a great tradition with inventive technology and fresh ideas.

NOTES
TO THE DRAWINGS

⟨✿⟩

1　Georgian doorway at the junction of Waterford Street and Lower Gardiner Street. The eighteenth-century houses of this area were rebuilt in the 1940s by Dublin Corporation as low-income flats, from which they swiftly degenerated into tenements, now the worst in the city.

FORMS AND PATTERNS: AN INTRODUCTION 2–9

2　Kildare Street. The gently satirical humour of the great Gothic stonemasons is nicely mirrored in the highly imaginative stonecarving of the Kildare Street Club. The Club, built in 1858, was designed by Dean and Woodward, who were also responsible for the Trinity College museum building.

3　Dame Court. An eighteenth-century alleyway connecting Exchequer Street with Dame Street.

4　Ardee Street. Bold patterns of brickwork indicate many variations of use in this fragment of an industrial building.

5　Beechwood Avenue, Ranelagh. The nineteenth-century suburbs of Dublin, stretching beyond the boundaries of the canals, produced many well proportioned and elegant small terrace houses such as this one in Ranelagh.

6　5 Castlewood Avenue, Rathmines. Rathmines, like Ranelagh, a village outside Dublin in the eighteenth century, became a middle-class suburb in the nineteenth. Walter Osborne, 1859–1903, the finest Irish painter of the late nineteenth century to be influenced by the French Impressionists, lived here.

7　Stephen's Green, South, the entrance to Newman's University Church. The church was designed in the form of a miniature basilica in 1854 by John Hungerford Pollen, a member of the Pre-Raphaelite circle. The most exotic of Dublin's group of Byzanto-Venetian buildings, it lies at the rear of the passageway between two eighteenth-century houses. The house on the left was built in 1765 and is now called Newman House; that on the right is early eighteenth-century and has a concealed gable and

characteristic string courses.

8　Westland Row. The terracotta frieze of floral swags and wreaths is an unusual feature of this terrace. Oscar Wilde, 1854–1900, was born in No. 21.

9　The River Liffey from Custom House Quay, looking down river towards Ringsend. The 250-foot gasometer on Sir John Rogerson's Quay was built in the 1930s and spanning the river is the modern Matt Talbot Bridge, commemorating a popular Dublin character, a reformed alcoholic and candidate for beatification.

THAT GOODLY COMPANY 10–25

10　Merrion Square North, No. 1. This commemorative plaque attempts to do justice to the myriad talents of Sir William Wilde, 1815–76.

11　Harcourt Street, No. 16. Bram Stoker, 1847–1912, had rooms in this house. Now remembered only as the author of *Dracula*, he was a prolific novelist and also theatre manager for Sir Henry Irving, the great Shakespearian actor.

12　Dorset Street, No. 12. Richard Brinsley Sheridan, 1751–1816, between his birth here and burial at Westminster Abbey acquired wealth and fame as one of the most successful of the eighteenth century's playwrights, yet ended his life in destitution.

13　Malahide Road, No. 28. William Carleton, 1794–1869, was living here in his early years as a writer when engaged on the *Traits and Stories of the Irish Peasantry*. His picture of mid-nineteenth-century

14 Merrion Square South, No. 82. W. B. Yeats, 1865–1939, lived here and maintained a 'salon' during his years as Senator in the Upper House of the new Irish Free State parliament.

15 Dean Street. The Minot Tower of St Patrick's Cathedral rises above the mean houses of the Liberties. Jonathan Swift, 1667–1745, Dean of the Cathedral, was born not far from here in Hoey's Court. He remains one of the oddest and most fascinating of the many eccentric geniuses of eighteenth-century Dublin.

16 Pembroke Road, No. 62. Patrick Kavanagh, 1904–67, the major Irish poet of the mid-twentieth century, had rooms in No. 62. He came to Dublin in 1939 and lived for many years in this nineteenth-century street.

17 Fishamble Street. George Frederick Handel, 1685–1759, lived for nine months in Abbey Street in 1741–2 during which the *Messiah* was first performed in the Fishamble Street Music Hall, now Keenan's Iron Works.

18 Westland Row, No. 21. Oscar Wilde, 1854–1900, was born in this house. The graceful combination of stucco and brick, wrought iron and glass sets a fitting scene for the appearance of the great aesthete of the 1890s.

19 Merrion Square South, No. 70. Joseph Sheridan Le Fanu, 1814–73, grandnephew of Richard Brinsley Sheridan, lived here for more than twenty years, eventually becoming a recluse. The palatial interiors of the houses in Merrion Square survive from their original purpose as town houses of the gentry and nobility.

20 Harcourt Terrace, No. 11. Sarah Purser, 1848–1943, lived and worked for many years in this Regency Terrace on the banks of the Grand Canal. Her studio can be seen on the left. She was co-founder with Edward Martyn of 'An Tur Gloinne', the stained-glass studios which led to a significant revival of that medium in Ireland.

21 Eccles Street, No. 7. James Joyce, 1882–1941, left Dublin for Europe in 1904 and lived the remainder of his creative life there. On 16 June 1904, Leopold Bloom left this house to become one of twentieth-century fiction's most well-known characters. The door itself is in the hall of The Bailey public house in Duke Street. The house, now reduced to its last remnants, is a place of pilgrimage on Bloomsday for devotees of *Ulysses*.

22 Werburgh Street. St Werburgh's Church, built in 1759 on the site of an earlier church, adjoins Hoey's Court, Swift's birthplace. The secluded graveyard lies between the church and the walls of Dublin Castle. John Field, 1782–1837, born nearby to a family of professional musicians, was baptized here. A virtuoso on the piano, his nocturnes were the first in a form made famous by Chopin.

23 Synge Street, No. 33. George Bernard Shaw, 1856–1950, was born here, spending his early years in an atmosphere of genteel poverty. This street, close to Portobello Harbour on the Grand Canal, reflects the living standards of the mid-nineteenth century lower-middle-class Dubliners.

24 Derby Square, Werburgh Street. James Clarence Mangan, 1803–49. John Mitchell in his 1859 preface to Mangan's *Collected Poems* describes Derby Square where the poet attended school:

> The houses are high and dingy: many of the windows are patched with paper; clothes lines extend across from window to window, and on the whole the place has the air of having seen better days, better, but never very good.

Derby Square has since been largely demolished, its name surviving on the Werburgh Street entrance. Clothes lines and broken windows remain constant to the little that does remain of the square.

25 The Brazen Head Hotel dates from the seventeenth century or earlier, and is approached by a passageway from Bridge Street, leading down into a stone paved courtyard. It was a meeting place of revolutionaries and intellectuals for many generations since the eighteenth century.

THE AGE OF REASON 26–43

26 The Printing House of Trinity College was designed by Richard Castle and built in 1735. It is fittingly symbolic of the source of the architectural expression of the eighteenth century in its guise as a diminutive Doric Temple, used here with all the decorative effect of a garden folly. The somewhat ridiculous frills of Liberty Hall rise in the background.

27 A fine pair of doorways in South King Street, built in a style which gives a monumental effect to such small houses.

28 The courtyard of the Royal Hospital at Kilmainham, designed by Sir William Robinson and begun in 1680, is viewed here from an attic window. The characteristic architectural forms of the

seventeenth century, of steeply pitched roof with dormers, tall chimney stacks, and the heavily mullioned windows below, can be seen. This building is now destined to become a conference centre for the EEC which will further maintain its inaccessibility. The plan of the Royal Hospital would be admirable for a museum or gallery and as such it could be part of the city's culture.

29 Interior of Archbishop Marsh's Library, also designed by Sir William Robinson in 1703, and properly called the Library of St Sepulchre, residence of the Protestant Archbishops of Dublin until 1803. The dark oak bookcases are the original furnishings, capped with mitred decorative scrollwork.

30 Ormond Quay viewed from Wellington Quay. Ormond Quay was the first of the great Dublin quays to be laid out and the model for the future development of the river banks. The houses are a very motley collection.

31 Henrietta Street, North Side. Early eighteenth-century town mansions of the nobility in what remained one of the most fashionable streets in Dublin until the Act of Union in 1800.

32 The contrasting modes of Thomas Newenham Dean's nineteenth-century Neo-Venetian bank and the more severe eighteenth-century entrance to Lower Castle Yard frame this view from Dame Lane into Palace Street, containing one of the many curious eighteenth-century charitable institutions.

33 The mania for wrought iron which characterized Dublin for so long is here seen at the junction of Ely Place and Hume Street on houses of the late eighteenth century, with some intrusive nineteenth-century chimneystacks and gables. Both George Moore and the notorious Lord Clare lived in Ely Place.

34 Pedimented doorway in North Anne Street and a
34A more austere example from Patrick's Close express the wide possibilities of design and pleasing contrast of materials which so effectively emphasized the entrance to a building.

35, The Rubrics doorway from Trinity College,
35A dating from the end of the seventeenth century, contrasts a collegiate air with that of a mid-eighteenth century domestic doorway in South Frederick Street.

36 This delightful passageway opening out onto the river at the Ha'penny Bridge runs under the Merchant's Hall. This Guild Hall was designed by Frederick Darley and built in 1821. Pavement bookbarrows have been a characteristic of the quays

of Dublin for at least a century.

37 A small and well concealed bird sanctuary is formed by the now disconnected basin of the Royal Canal, which is seen here looking into Blessington Street, with the fine spire of St George's, Hardwicke Place, in the distance.

38 Parliament Square of Trinity College with its lawns and cobblestones and the main entrance from College Green under the Corinthian portico, which is the mirror image of the street façade.

39 Baggot Street began under the unpromising name of Gallows Lane. This tree-lined late-eighteenth-century street is one of the most pleasant areas of central Dublin.

40 Kildare Street, No. 5. The basement area protected by street level wrought-iron railings with an unusual dated example of the cisterns common to eighteenth-century basement areas. The arms are of Arthur Pomeroy, 1st Viscount Harberton.

41 Beautifully detailed horse trough and drinking fountain of limestone and polished grey granite on Cavendish Row, now under constant threat from traffic. The design is more reminiscent of a Baroque altarpiece than of its rather mundane function.

42 Entrance to No. 11 North Great George's Street. One of those remarkably eccentric examples of an eighteenth-century doorway.

43 Fownes Street, between Dame Street and the river, has some interesting early houses reminiscent of the proportions of the Royal Hospital.

LIBERTIES AND SHAMBLES 44–53

44 Adelaide Road horse trough. Like so much of the mews architecture of central Dublin which has disappeared, few horse troughs remain, and even fewer horses.

45 Gardiner Place. A typical doorway of the late eighteenth century, missing its fanlight. The graffiti remains an emotive one in Irish terms.

46 Parnell Street street market is at the north end of O'Connell Street and central to one of the poorest areas of the city.

47 The desolate 'playground' behind the cannibalized eighteenth-century houses of Sean McDermott Street and Lower Gardiner Street.

48 Crampton Court, between Essex Street East and Dame Street. The passageway led to a now demolished small square.

49 Paradise Place, off Granby Row, a service street

between the great eighteenth-century terraces of the north city.

50 Lower Stephen Street. Decaying street to the west of Stephen's Green. Timber levelling courses can be seen in the brickwork on the corner of Digges Lane, which previously went under the name of Goat Alley.

51 Meath Street, heart of the Earl of Meath's Liberty and the first Liberty of the city. The Dublin Mountains end the vista – a characteristic element in Dublin of the relationship of city to country.

52 Warehouse entrance in Kevin Street Upper. The inscription suggests an age in which all waste had its value.

53 North Great George's Street. The majority of the tenants of the magnificent eighteenth-century streets north of the river, of Henrietta Street, North Great George's Street and Mountjoy Square, are now convents, public institutions and tenements, the latter of unbelievable squalor, no more than vertically stacked tinker encampments.

BELIEF 54–69

54 Wayside shrine in Upper O'Connell Street.

55 St Patrick's Cathedral, openwork spiral staircase in the north transept. It leads to the organ loft and was designed by Sir Thomas Drew in 1901, based on ideas derived from prototypes in various European Gothic Cathedrals.

56 Emmet Street with the Free Church, Great Charles Street in the background. The triple range of roof ridges in the foreground is typical of a style prevailing in Dublin since the eighteenth century from mansion to working-class cottage.

57 Essex Quay from Ormond Quay, with the buildings in Exchange Street (formerly Blind Quay) seen through the demolished areas of the quay. The church of SS Michael and John was built in 1815 – occupying the site of the seventeenth-century Smock Alley Theatre.

58 The last houses in Protestant Row, off Wexford Street.

59 Ballybough Jewish Graveyard, Fairview Strand, once the centre of a Jewish area of the city. The caretaker's lodge was built in 1858, although the graveyard dates from 1718, nearly a century and a half earlier.

60 Lord Leitrim's family vault where the coffins and corpses are preserved by the high methane content of the air.

61 The seventeenth-century vaults of St Michan's run north-south as a series of unconnected passageways beneath the church.

62 The now disused church of St Peter, between Aungier Street and Peter's Row, is one of the many churches orphaned by the shift of population to the suburbs. The tombstones and the history they recorded barely survive.

63 Wayside shrine in Gardiner Place in the basement area of one of the many Georgian houses occupied by charitable institutions.

64 Side entrance to St Patrick's Deanery in Kevin Street, Upper.

65 Grace Baptist Church in the Brunswick Hall lies at the end of this brick-arched passageway from Pearse Street.

66 This view of Grattan Bridge is dominated by the spire of the church of SS Augustine and John, Thomas Street, although four of the city churches are gathered together in a relatively small area. These are the nineteenth-century St Aouden's, SS Augustine and John, and the Adam and Eve Church. The medieval St Aouden's can also be seen, as well as the onion tower of Guinness's Brewery, originally a windmill.

67 The Huguenots, or French Calvinists, came to Dublin to escape persecutions under the Edict of Nantes in the seventeenth century. Now merged with the Irish population, separate worship and burial as in this graveyard on Merrion Row has long ago ceased.

68 The Church of SS Augustine and John, or John's Lane Church, from Usher's Quay, showing the natural rise in the land from the Liffey which recommended the site for settlement by the Vikings.

69 Plaque of a business premises in Parnell Square West. The 'frilling' lends a touch of frivolity to this sombre trade.

THE MEDIEVAL CITY 70–77

70 The south doorway of Christ Church Cathedral with its characteristic chevron design of the Hiberno-Romanesque style, here executed in an openwork manner which gives extra depth to the carving.

71 From the left Fishamble Street, High Street, the Cathedral Chapter House, spire of St Patrick's Cathedral, Christ Church Cathedral, Winetavern Street, Synod Hall and tower of St Michael's

Church; in the foreground Wood Quay with the Viking and medieval excavations between the brow of the hill and the river.

72 The Minot Tower of St Patrick's Cathedral from the west. The approach to the Church of SS Nicholas and Luke (Extra Muros) stretches across the foreground with the Alms House of the parish appearing above the long wall.

73 The twelfth-century Cistercian Abbey of St Mary which gave its name to Abbey Street has disappeared, with the exception of its chapter house which is now buried beneath a warehouse in Meeting House Lane off Capel Street.

74 The narrow winding staircase inside the Postern Gate in the city wall gave access from the ramparts to the area outside the walls between St Aouden's Gate and Fagan's Castle to the west.

75 The one surviving city gate derives its name from St Aouden's Church perched above it, the only medieval parish church unaltered in the eighteenth century. Partially roofless, the nave continues to be used.

76 The medieval-looking but probably later buttresses on the north face of the City Wall at Cook Street.

77 Thundercut Alley, looking towards Smithfield, is not medieval, yet with its narrowness, heaps of garbage and doubtful safety it might well represent a street of the middle ages, though its straightness indicates its later date.

CASTLE AND CROWN 78–87

78 The 'five devils of Kilmainham' by an unknown sculptor. This bas relief is an usually placed example of contemporary interest in chinoiserie.

79 Gate to the upper yard of the Castle from Cork Hill. The statue above the baroque arch is of Justice, while its counterpart, of Mars or Fortitude, stands over a blind gate within the Castle yard.

80 The Stonebreakers' Yard in Kilmainham Prison in which the prisoners worked in cubicles (now removed) breaking stone for roadworks. It was here that Pearse, Connolly and the other leaders of the 1916 Rebellion were shot.

81 The exterior of Kilmainham Prison from across the Camac River. The glazed barrel vault of the central enclosure can be seen on right.

82 State architecture at its most impressive. A small detail of the entrance to the Registry of Deeds in the King's Inns.

83 The bronze statue of Queen Victoria which stood for a mere forty years from 1908 in the forecourt of Leinster House in Kildare Street. Now it rests, with other relics of imperial grandeur, in the quadrangle of the Royal Hospital, Kilmainham. The Royal Hospital is built on the lands of the Priory of the Knights Hospitallers of St John of Jerusalem which was suppressed during the Reformation.

84 Mountjoy Jail, built in the mid-nineteenth century and still in use, is the setting for Brendan Behan's play *The Quare Fellow*, based on his personal experiences while imprisoned there. Its forbidding walls and towers loom over the nearby banks of the Royal Canal.

85 The junction of Great and Little Ship Streets, with the eighteenth-century Castle steps and entrance. The oval medallion on the pier of the left-hand arch commemorates Dean Swift whose birthplace is nearby. The Irish form of the street name preserves its original meaning, Sheep Street. The English is a corruption of 'Sheep' into 'Ship'.

86 The 1798 Corridor in Kilmainham Prison in which the leaders of that rebellion were held. The prison had been in use for only two years in 1798. It was designed by Sir John Traill, the High Sheriff of Co. Dublin. The prison is now a museum of Irish political history.

87 Dublin Castle. View from the south of the medieval City Wall with the Records Tower between the State Apartments and the former Chapel Royal.

CONCLUSION 88–90

88 Doorway in Summer Row off North Summer Street with an interesting frieze of swags and goblet.
89 The Swift inscription in Ship Street.
90 No. 5 the Coombe.

PANORAMA

A view of the city of Dublin from the tower of St Michan's Church on the North Side of the Liffey, showing in the foreground, from the Four Courts to St Paul's, Arran Quay, and south of the river, from Christ Church Cathedral to St Catherine's, Thomas Street, with the layout of the city and the Dublin mountains in the background.

PANORAMA

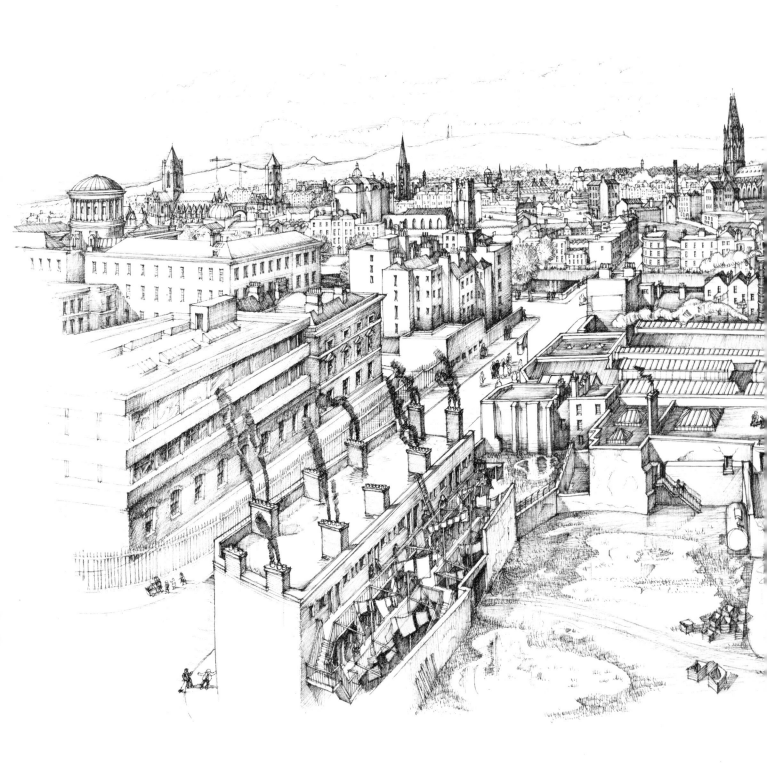